CHARLOTTETOWN

Nimbus Publishing Limited
PO Box 9166
Halifax, NS B3K 5M8
(902) 455-4286

Printed and bound in Canada
Design: Kate Westphal, Graphic Detail Inc., Charlottetown, PEI
Photo captions by Catherine Hennessey

Library and Archives Canada Cataloguing in Publication

Barrett, Wayne
Charlottetown : photographs / by Wayne Barrett and
Anne Mackay ; with an introduction by Catherine Hennessey.
ISBN 1-55109-515-7

1. Charlottetown (P.E.I.)—Pictorial works. I. MacKay, Anne II. Title.

FC2646.37.B37 2005 971.7'505'0222 C2005-901384-2

We acknowledge the financial support of the Government of Canada through the Book Publishing Industry Development Program (BPIDP) and the Canada Council for our publishing activities.

The Canada Council | Le Conseil des Arts
for the Arts | du Canada

Cover

Front: Beaconsfield, located at the gateway to Victoria Park, has many stories to tell. Built in 1877 by shipbuilder James Peake, Jr., Beaconsfield was recognized as one of the finest residences in the town—another proud achievement of architect W. C. Harris, who was a mere twenty-three years old at the time it was built. Peake lived in the house for only six years.

Henry Cundall, a prominent businessman, surveyor, and dedicated diarist, took the house over and lived in it until 1917. The Cundall Trust that he established to support good works leased the house to the Prince Edward Island Hospital as a nurses' residence. The Prince Edward Island Museum and Heritage Foundation acquired the house in 1972 and had it refurbished. Queen Elizabeth officially opened the foundation's new headquarters in July 1973.

Back: The gorgeous front doors of Fairholm have been the entry point for many memorable Charlottetown parties, as this excerpt from the Guardian, August 7, 1903, suggests: "One of the most enjoyable balls in Charlottetown for a long time was given last night at Fairholm, the residence of Benjamin Rogers Esq. and Mrs. Rogers. The grounds were beautifully decorated with Chinese lanterns, etc...Music for dancing was furnished by Miss Smith and nearly one hundred guests were in attendance. The occasion was a notable one in the social life of Charlottetown."

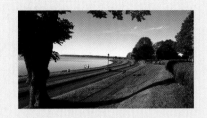

CHARLOTTETOWN

PHOTOGRAPHY BY

WAYNE BARRETT AND ANNE MACKAY

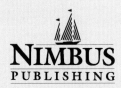

NIMBUS
PUBLISHING

Mount Edward Road near Charlottetown P.E.I

IV CHARLOTTETOWN

INTRODUCTION

On the Island, Charlottetown was an old-world seaport, like an old-fashioned child, with a Government House, visits of naval ships and the romance of the tall white schooners of the West Indian trade.

—Stephen Leacock, *Canada: The Foundations of its Future*, 1941

Official seal of the city by George Thresher, 1855.

Facing page: "Ravenwood and Ardgowan" by Robert Harris, Confederation Centre Art Gallery Collection.

Beloved Canadian writer Stephen Leacock's description of Charlottetown reveals the sense of romance associated with the capital city in its early days. Today, the people of Charlottetown aim to keep the best of that picture alive as the city faces the twenty-first century.

Charlottetown is a small city, but as the capital city of Canada's smallest province, it carries more weight than most places of similar size. Its attributes are many: a provincial legislature and a strong federal presence; good schools and modern hospital facilities; a university with a prestigious veterinary college; a technical college; a thriving arts community; and plenty of sports activities, including a golf club and yachting on the waterfront. Charlottetown is indeed a fortunate community.

This is the Charlottetown of today, but it is also important to look deeper and consider how historical events have shaped the community. It is not a young town, and has withstood many influences over the years.

When Charlottetown was incorporated on April 17, 1855, it was already a reasonably well-established place with international connections. Its beginnings can be traced to the appointment of Captain Samuel Holland on March 23, 1764, to conduct a general survey of British North America, north of the Potomac River, on behalf of the king and under the direction of the Lords of Trade and Plantations. He was to begin with the Island of Saint John, now known as Prince Edward Island. He arrived on the Island in October 1764.

Holland's enduring influence on the Prince Edward Island landscape is extraordinary: The sixty-seven lots that he laid out would determine settlement patterns across the Island, patterns that have shaped the economic, industrial and political structures reflected in the province to this day. It is no exaggeration to say that Holland's initial decisions of land allotment form the bones of the history of Prince Edward Island.

Holland located three towns on the Island, all with a lovely southwestern exposure: Princetown (in Prince County), Georgetown (in Kings County) and Charlottetown (in Queen's County). He chose sites primarily for their water access and their possible role in defense.

Holland first refers to the importance of Charlottetown to the colony in a letter to his superiors in London, dated October 8, 1765:

The Capital called Charlotte Town is proposed to be built on a point of the Harbor of Port Joy, betwixt York and Hillsborough Rivers, as being one of the best, and nearly central Parts of the Island; has the Advantage of an immediate and easy Communication with the interior Parts by means of the three fine Rivers of Hillsborough, York and Elliot.

The Ground designed for the Town and Fortification is well situated upon a regular Ascent from the Water Side: a fine Rivulet will run through the Town… as this Side of the Island cannot have any Fishery, it may probably be thought expedient to indulge it with some particular Privileges; and as all judicial and civil, as well as a good part of the commercial Business will be transacted here, it will make it at least equally florishing with the other County Towns.

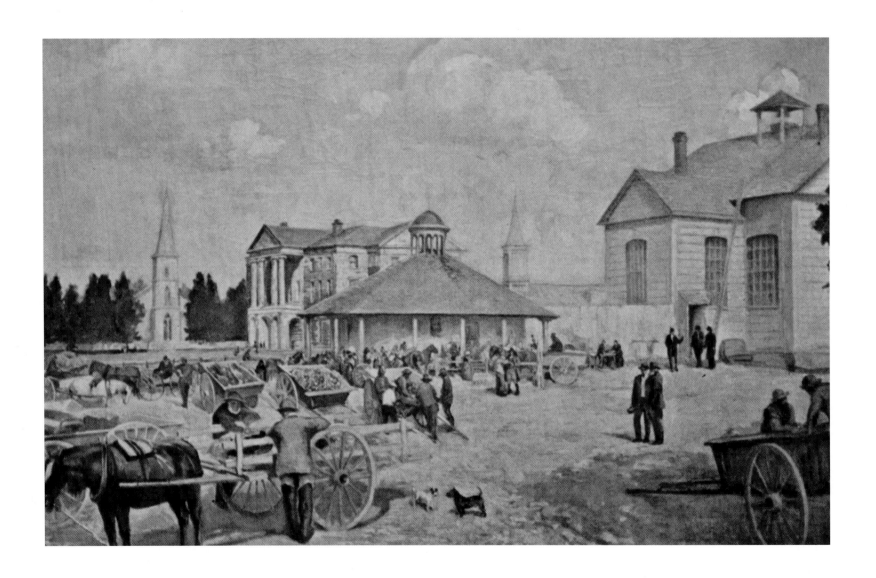

VI CHARLOTTETOWN

This was truly Charlotte Town's birth announcement.

Named by Samuel Holland after Queen Charlotte, the wife of King George III, Charlottetown began its days as a brand-new town on a virgin site across the harbour from Port La Joie, the capital of Isle St Jean during the French Regime. Its confirmation as the capital of the Island was made by Franklin, the lieutenant-governor of Nova Scotia, under whose jurisdiction the Island remained until 1769. It was he who directed Charles Morris, the Halifax surveyor, to begin laying out the town.

Orders from London defined how the towns in the colonies were to be laid out. By 1763, the Lords of Trade and Plantations sent directions indicating how the land should be reserved: an ordinance grounds, a King's store near the water, barracks for troops, a seat for government—and even a garden! There was also to be land for a court house, a burying ground, a church and a parsonage. Even more specficially, they wanted a grid of streets and blocks, and a central public square surrounded by four or more green spaces. With Morris' plan adapted somewhat by Island surveyor Thomas Wright on the insistence of Lieutenant-Gover-

nor Patterson, Charlottetown had it all—and the essence of this original infrastructure still exists today.

Relatively early in Charlottetown's history, the land began to develop into Common and Royalty lands, forming country estates reminiscent of the English countryside that was the homeland of many of the early settlers. In Charlottetown's early days, people had their homes downtown and their farmlands in the outskirts. The farmland was essential, not just to grow crops and feed families, but also to feed farm animals. Downtown, most families had one or more horses, often a cow, and perhaps a pig or two. There are many references to animals roaming around the town where they shouldn't have been!

As the Island's history is strongly linked to the sea, it is not surprising that town settlement began along the waterfront and near the military compound that had been established to protect it. As the town grew, the wharves increased in number and activity. Soon, Charlottetown was a bustling international harbour: ships came and went from the British Isles, the Caribbean, the United States and from all around the world. Settlers arrived on the Island and made it their home, and

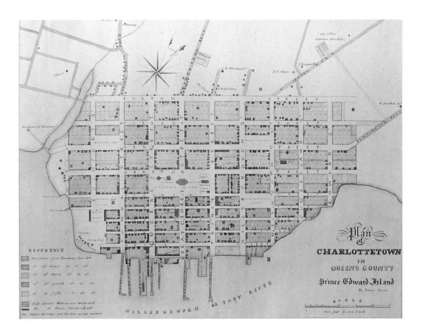

INCORPORATION ACT.

An Act to Incorporate the Town of Charlottetown.

[*Passed April 17th, 1855.*]

WHEREAS, for the better protection, care and management of the local interests of the inhabitants of the Town of Charlottetown, and for its Municipal Government and improvement, it is expedient that the said Town be incorporated:—Be it therefore enacted, by the Lieutenant Governor, Council and Assembly, as follows, that is to say: That the inhabitants of the said Town of Charlottetown and Common, and their successors, inhabitants of the same, from and after the passing of this Act, shall be, and they are hereby constituted a Body Corporate and Politic, in fact and in name, by and under the name, style and title of the City of Charlottetown, and as such shall have perpetual succession and a common seal, with power to break, renew and alter the same at pleasure;

Map of the 500 lots by Robert Harris, Confederation Centre Art Gallery Collection.

Facing page: "Queen's Square in Early Days" by Spencer McKay, City Hall Collection.

Overleaf: Nineteenth-century waterfront with sailing ships, DuVernet Collection, Public Archives of PEI.

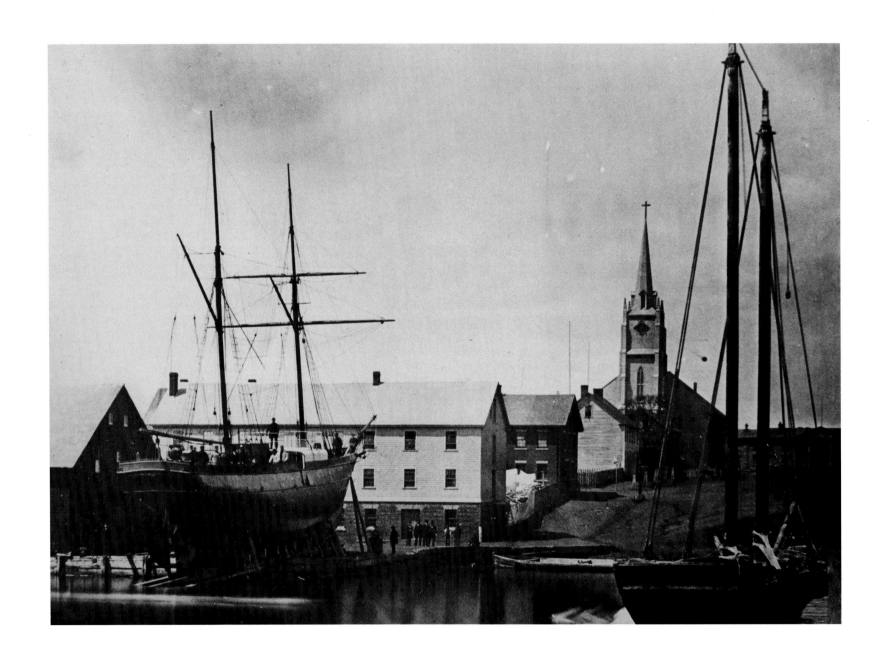

VIII CHARLOTTETOWN

those with incurable wanderlust left to seek their fortunes elsewhere. To support this strong maritime activity, ship building—with its related trades—soon spread out along the town's waterfront. Trade with nearby places was constant, and the arrival of ships from the exotic Caribbean carrying rum, sugar and molasses or from England added greatly to the excitement and hum of the town.

After the garrison left in 1865, shipbuilding and trade became the major influences shaping the Charlottetown of the nineteenth century. The beautiful houses, churches and public buildings that are proudly protected today are a product in one way or another of that time. There is little doubt that the impact from the Age of Sail is still felt today.

In the latter quarter of the nineteenth-century, the age of steam brought many changes in Charlottetown's working harbour and way of life. Much of the waterfront became a large, fenced-in space, ready to hold the big machines and all the activity of the railway. With the steady salaries the railway provided, the town saw extensive expansions in housing, particularly on the east side. Also due to the railway, town life began to revolve around the train schedules. The arrival of the mid-morning trains from the west and the east provided a steady stream of people through Hillsborough Square to uptown ready to buy and sell. Popular wares might include farm produce, spring mayflowers, Mi'kmaw baskets and clothes poles. For many, business would often commence after a good stiff drink at their bootlegger of choice. Bankers, doctors and lawyers knew that if the weather was fit their day would be full between trains. When the trains left mid-afternoon the town returned to normal, until the arrival of the evening train—the boat train from the mainland. Part of Charlottetown's social life revolved around the arrival of the evening train. Over the ninety years of passenger service, the train connected Islanders from one end of the province to the other.

Charlottetown's waterfront continued to be a place where rail and shipping mixed until the last quarter of the twentieth century. While the influence of the automobile grew, the railway slowly began to decline. It closed down completely on December 28, 1989, thus closing a chapter on a significant era of waterfront activities.

The impact of the automobile age is still dawning upon Charlottetown. The city's downtown has lost many buildings and much green space to parking. Meanwhile, the urban sprawl continues. The trucking industry, as well, has been leaving its mark—there is centralization of distribution companies, a move to "big box" stores and the delivery of everything from prepared foods to furnace oil. Wholesalers and many industries moved to the outskirts of town. Except for the activity of the yacht club, the once-bustling waterfront started to take on a forlorn look.

Charlottetown's rich past, however, has not been abandoned. In a pro-active move recognizing the importance of protecting the original core of the city, the Charlottetown Area Development Corporation was established in 1970. Left with a waterfront that was fast being deserted by one business after another, and finally by the railway itself, the corporation reawakened the potential in Charlottetown's downtown and waterfront resources. As a result, Charlottetown's history has not been neglected; as a matter of fact, it has been carried with pride into the twenty-first century.

Today, residents of Charlottetown can live in accommodations with water views. Visitors and people from the area can walk along the boardwalk from one side of town to the other. Sailors can moor their boats and sail, minutes from downtown, in one of the finest harbours anywhere. The harbour's working roots have not been lost, either: you can still load a cargo of potatoes or unload the fertilizer that will make them grow better. Prince Edward Island's capital city has proven to be as full of potential as Captain Holland envisioned back in 1765.

As the city reviews its 150 years of incorporation, it is clear that Charlottetown continues to build on its fine bones. We might still be the smallest capital in the country, but we have amenities that give comfort to our daily lives, enrich our cultural life and give joy to our spirits. It is a town we delight in sharing with our visitors and friends. Just have a look.

—Catherine Hennessey

Catherine Hennessey is a Charlottetown-born heritage activist.

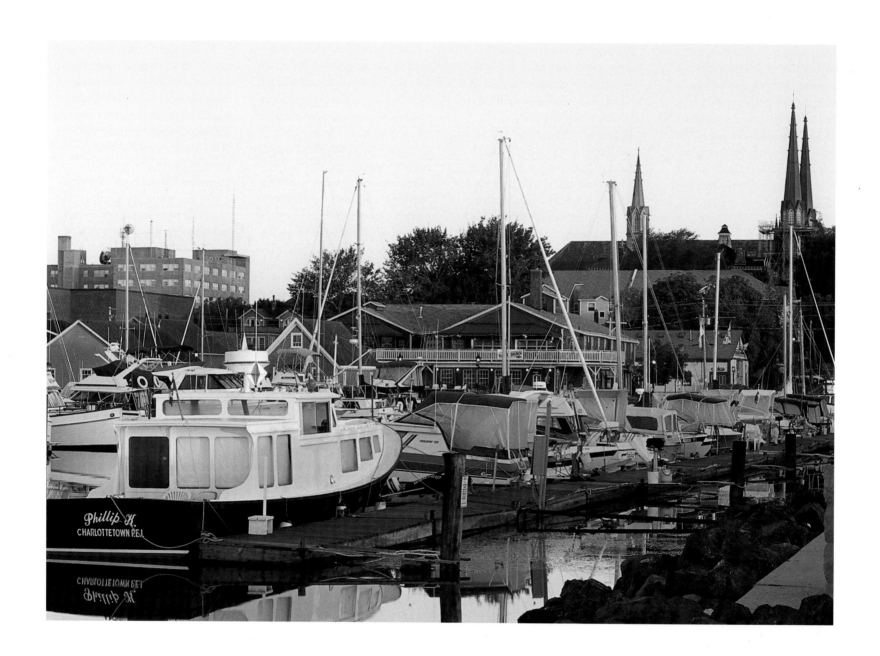

X CHARLOTTETOWN

"The trees planted throughout the city during the last three or four years are already beginning to have a picturesque effect. Many portions of the town where trees have been allowed to grow for 30–40 years are now beginning to have the appearance of old-fashioned quietness and ease which is always so delightful a feature of old cities…"

From the Daily Examiner, July 3, 1890, under the title "Beautifying the City." It is truly so that Brighton Road shows the results of the tree planting efforts of long ago.

Facing page: Today, Charlottetown's busy waterfront still teems with boats and activity.

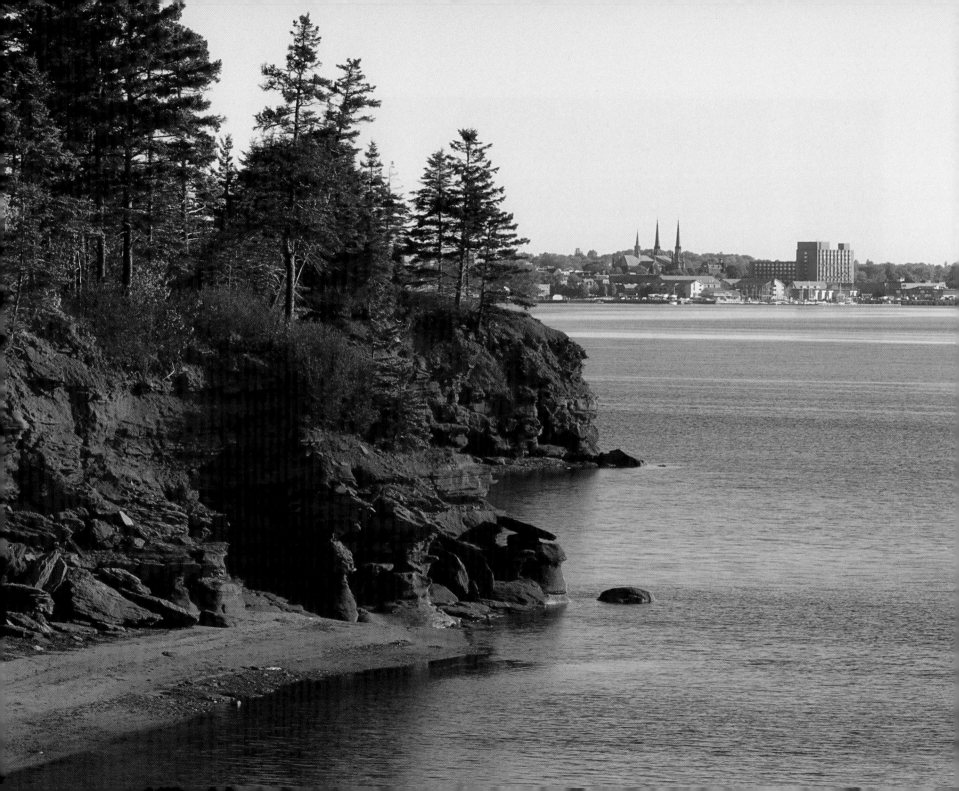

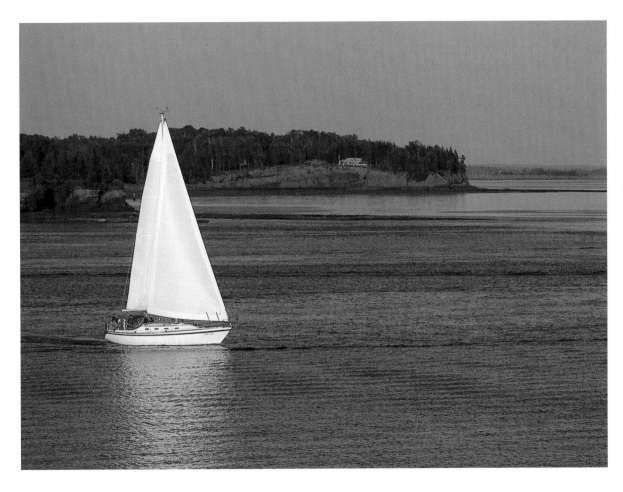

No greater peace can be found than on a summer evening sailing on Hillsborough Bay. Nearby to Charlottetown, the bay provides boaters a chance to enjoy the breezes of the bay with a view of the town from a different perspective.

Facing page: "On the morning of October 1, we entered Charlotte Town Harbour. The entrance is about a mile or 3/4 mile wide, and the town from thence looks very pretty. It is situated on a gently rising ground between two creeks or arms of the sea, which, with another creek and the entrance make a cross, the centre point of which is opposite the town and forms a harbour," from a Beazeley family letter to England, describing the first sighting of the town. The Beazeleys arrived from England in 1849 to settle on Prince Edward Island.

*Mavor Moore, Norman and Elaine Campbell,
and Don Harron brought Lucy Maud
Montgomery's* Anne of Green Gables *to
wider audiences in a musical by the same name.
First performed on the main stage of
Confederation Centre of the Arts in the summer
of 1965,* Anne of Green Gables *has been the
cornerstone of the Charlottetown Summer
Festival ever since.*

*The Confederation Centre of the Arts provides
the community with a theatre, an art gallery,
and a library, all in the centre of town. Prime
Minister Lester B. Pearson opened the centre as
a memorial building to the Fathers of
Confederation in October 1964, dedicating it to
those famous men. He also dedicated it to "the
fostering of those things that enrich the mind
and delight the heart, those intangible but
precious things that give meaning to a society
and help create from it a civilization and a
culture."*

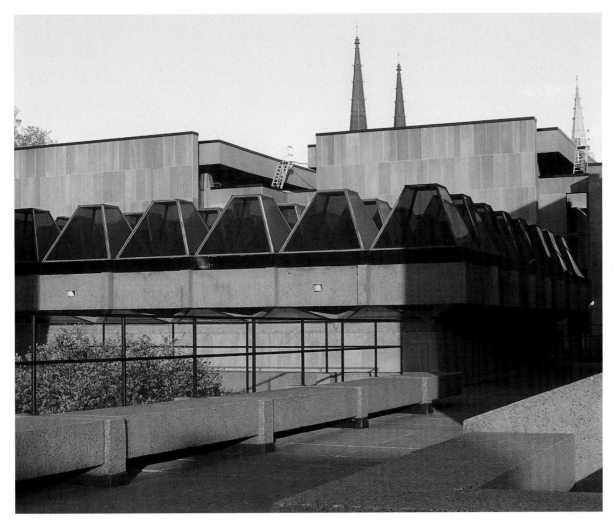

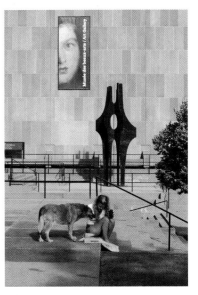

On the plaza of the Confederation Centre Art Gallery, "Centennial Dimension," a sculpture by local artist Henry Purdy, viewable on the Wallace sandstone. The gallery is home to an extensive collection of Canadian art, including the work of famous Canadian artist—and Islander—Robert Harris. The gallery's program of changing exhibitions adds richness to the town's vibrant cultural scene. Art lessons, an art rental program, and a variety of lectures provide Islanders with more understanding of Canadian visual art than one might expect in a place of this size.

"The Colonial Building, since Confederation known as the Province House, has witnessed many brilliant functions, dejeuners, dinners and balls, to distinguished visitors, British and American and Canadian. It has been the community centre; legislative, administrative, social and intellectual. The most fateful if not most brilliant function was the Charlottetown Conference of September 1864 which adjourned to Quebec in October and formulated the resolutions which became the basis of Confederation." So wrote D. C. Harvey in the Guardian *of April 16, 1932.*

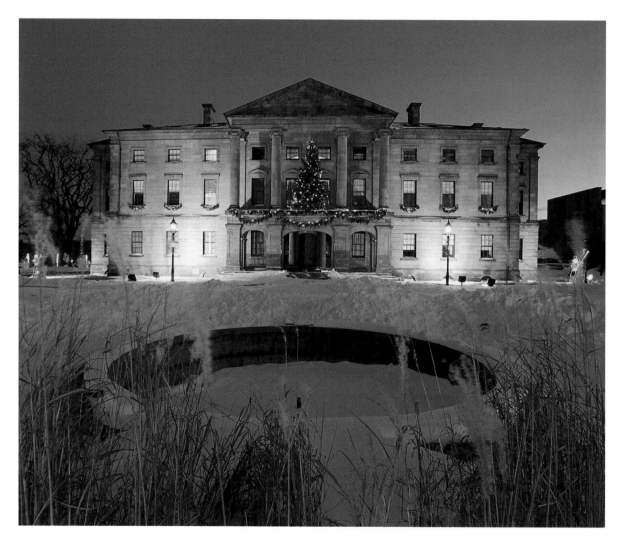

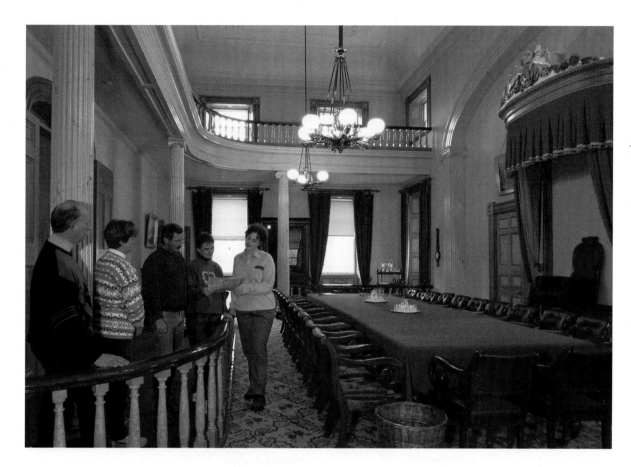

It was in this room in the Colonial Building that the delegates to the Charlottetown Conference met. "At the Conference [of the Fathers of Confederation at Charlottetown]... we all approached the subject...feeling that in our hands were the destinies of a nation. That there are difficulties in the way would be folly of me to deny, but what great subject has not been fraught with difficulties? We would not be worthy of the position in which we have been placed by the people if we did not meet and overcome these obstacles [to the noble cause]...a people, able from our union, our strength, our population, and the development of our resources, to take our position among the nations of the world." Sir John A. Macdonald, September 1864.

The chamber in which the conference met remains much as it was in 1864.

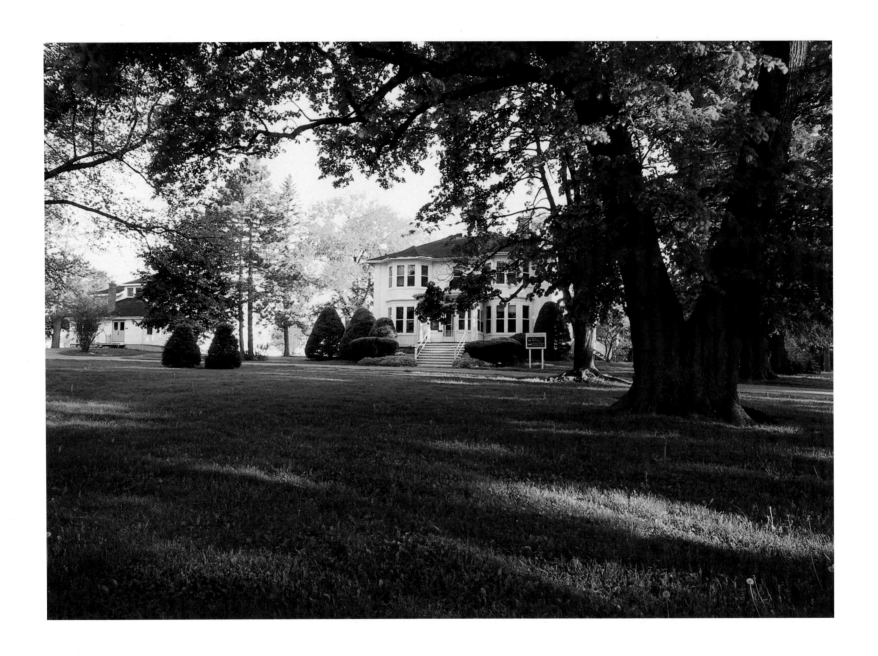

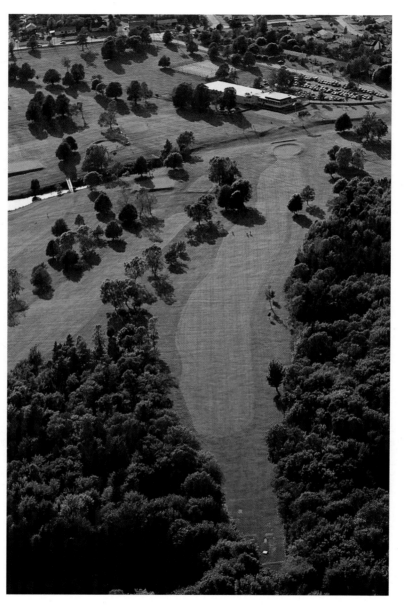

"The playing of golf—which was begun in a mild way in Charlottetown last autumn—is to be entered into enthusiastically, this spring." So stated the Examiner in May 1903.

The Belvedere Golf Club, which was built on the Beazeley Estate in 1904, is located on the edge of downtown, and is one of Charlottetown's richest resources. A source of great enjoyment for over one hundred years, the eighteen-hole golf course is just minutes from anywhere in Charlottetown.

Facing page: "Description of Prince Edward Island," published in 1822, describes a trip east of Charlottetown: "A little way from town, on the north west side, the Attorney General's house a very neat and commodious house stands upon a fine rising ground with several beautiful well cultivated inclosures around." This is an apt description of Ravenwood, a house built about 1820 by Johnstone, the colony's attorney general. Today, the house is the central piece of the property that since 1910 has served as the Dominion Experimental Farm and Research Station (recently moved to the outskirts of town). It is the community's hope that this important estate will be turned into a major park in the capital city, one that will commemorate the early occupants of the house and all those who have made agriculture such an important part of island life.

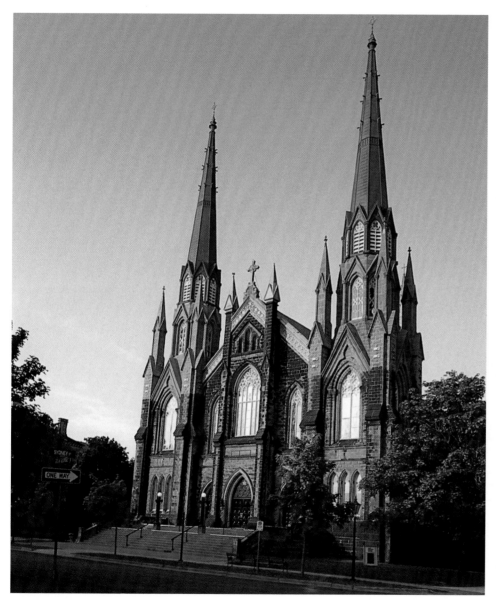

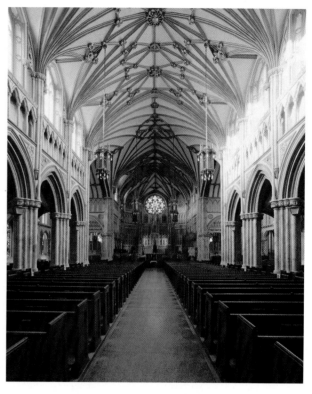

J. M. Hunter, a Charlottetown architect who redesigned the interior of St. Dunstan's Basilica after the 1913 fire, was strongly influenced by the High Victorian Gothic designs of the 1880s and by the interior of St. Patrick's Cathedral in New York. It was these features and the historical importance of the church in the community that led to its designation as a National Historic Site in 1996.

St. Dunstan's Basilica was built between 1896 and 1907 in High Gothic Revival style by Francois-Xavier Berlinguet, a Quebec architect trained in the building traditions of that province. Sadly, less than six years later, a serious fire destroyed all but the walls. With incredible determination and public support, the dioceses began again. This magnificent building was re-opened on September 24, 1919.

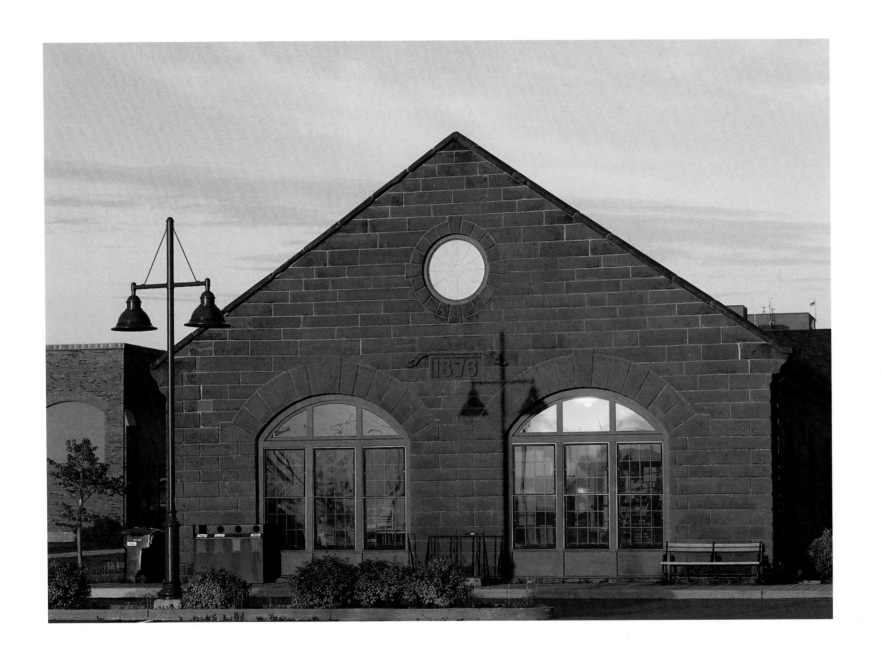

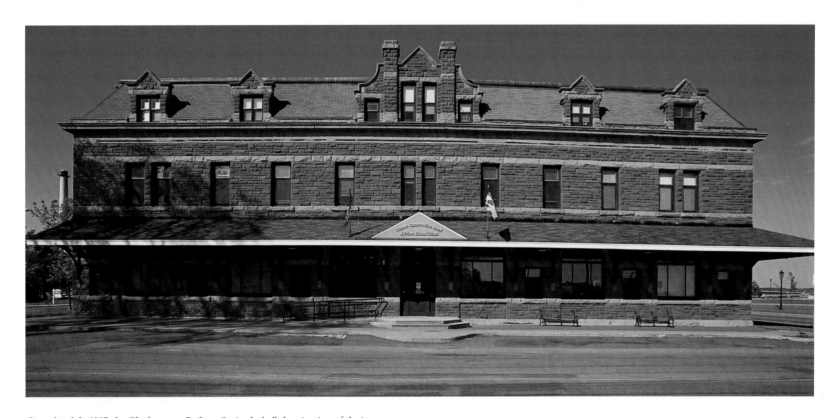

Opened in July 1907, the Charlottetown Railway Station had all the trimmings of the important stations in the country, such as a big umbrella roof along the east side to protect passengers as they came and went, a separate waiting room for women, and an efficient baggage room. With the railway's demise, the building was refurbished into useful office space. It still makes a fine architectural contribution to Charlottetown's east end.

Facing page: Now a Tourist Information Centre, this 1876 island stone building was once an active centre in the midst of the railway yard. Known as the Brass House, it had stood amidst a place of tracks and trains, the car shop and the round house. The fenced-in railyard was a bustling site of industry, clickity-clack sounds and steam and whistles.

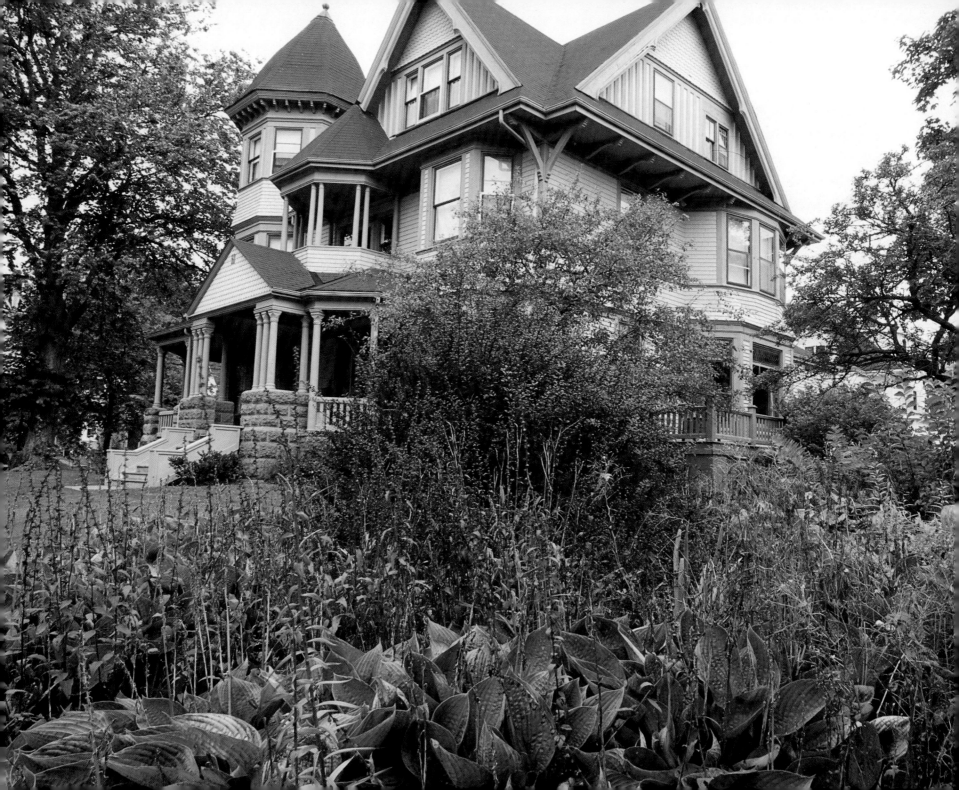

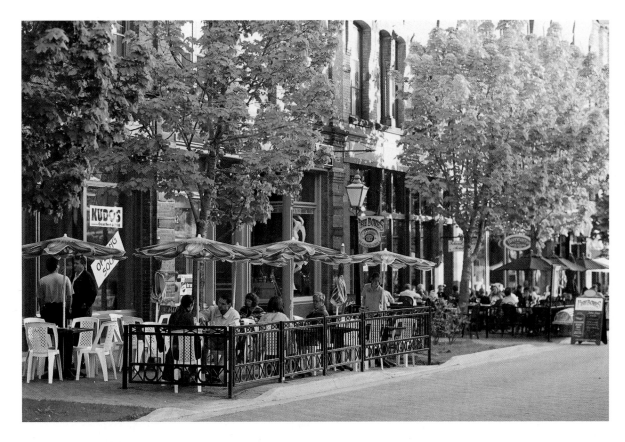

Charlottetown's most handsome row of buildings provides the backdrop for one of the town's popular summer gathering spots. Restaurants, arts and crafts shops, and the stage door of the Confederation Centre give the place its character. Built in the late nineteenth century between Queen Victoria's Jubilee years, it acquired the name Victoria Row. An iron arch creates a welcoming entry point from Queen Street.

Facing page: Wine merchant James Eden built this wonderful Queen Anne Revival style house that he had designed by C. B. Chappell in 1897. The principal rooms were finished in oak and the drawing room in sycamore. It is clear that no cost was spared in the building of the house. George DeBlois lived there when he was appointed lieutenant-governor in 1933, one of no less than four lieutenant-governors to live on West Street over the years.

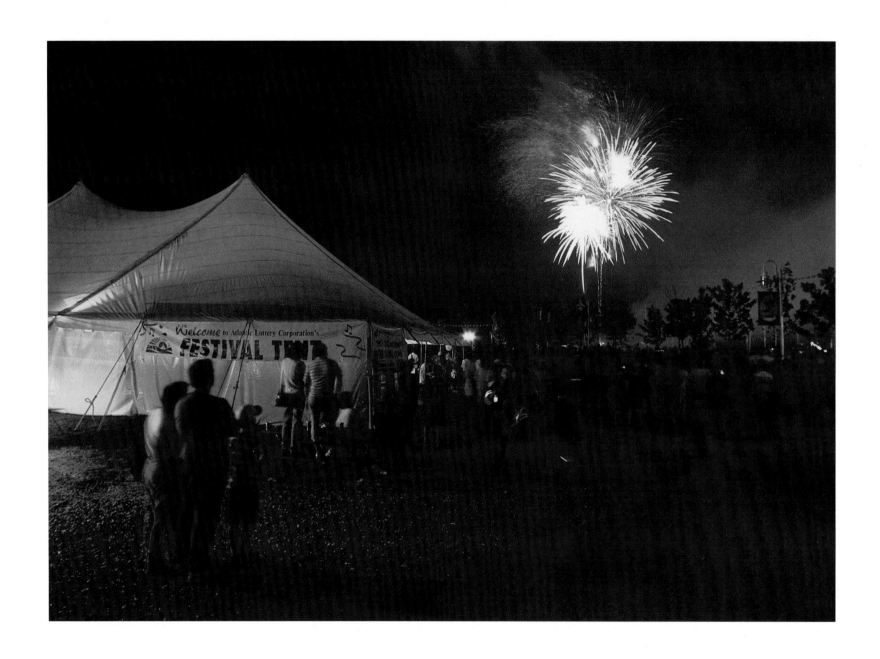

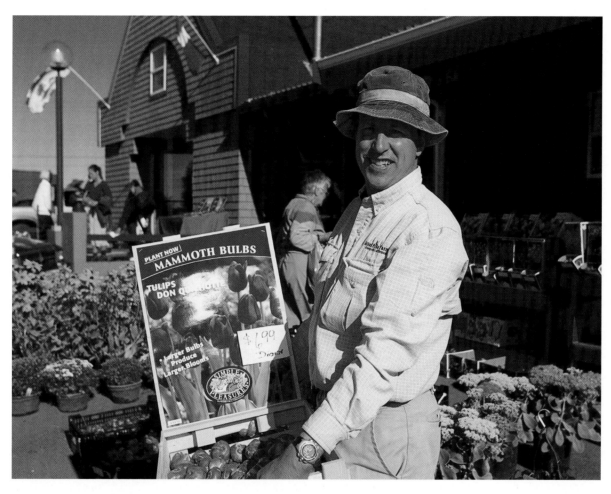

Our friend John comes to market days with the best that Wood Islands air can provide and gardening advice to go with it. He follows a long market tradition that sees rural Islanders coming to Charlottetown with their goods. The faces and some of the wares have changed, but the flavour is the same. Weekly market days are social events not to be missed.

Facing page: Since its establishment in 1995, Confederation Landing Park, on the waterfront at the bottom of Great George Street, has become one of the town's gathering places in both summer and winter. Built to commemorate the arrival of the Fathers of Confederation in September 1864, the park is perfect as a place for quiet repose or a night of brilliant fireworks. It was designed by a Toronto firm, Hough Stansbury, Woodland Ltd, after a national competition.

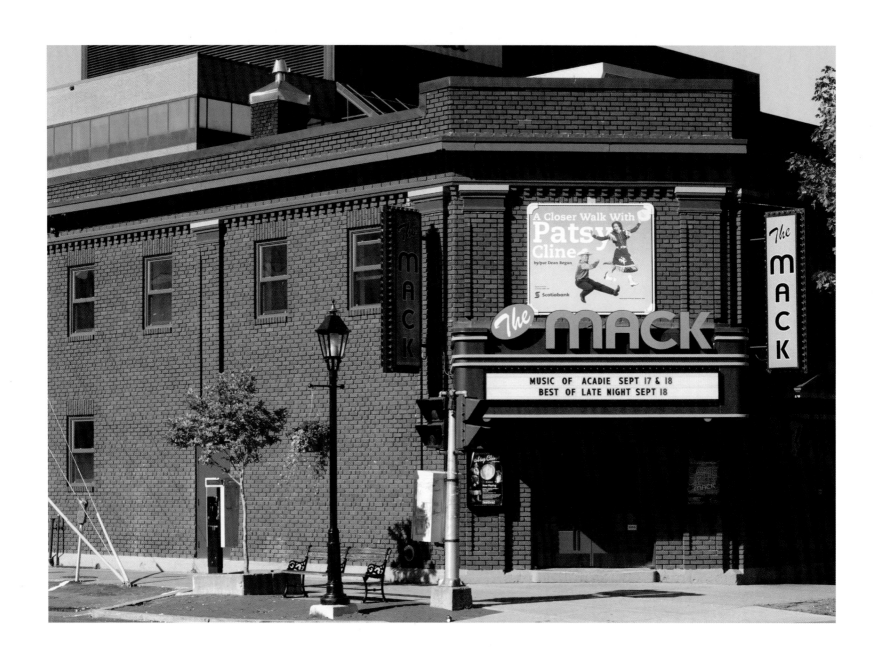

This building at the corner of Great George and Richmond Street, built for the Union Bank in 1872, is an excellent example of the Italianate style common in the period. A fine cornerstone to one of Charlottetown's most impressive blocks, the building now houses government offices and a training centre.

Facing page: "The building is a creditable and attractive addition to Mr Spencer's chain of moving picture houses in the Maritimes...." States a Guardian headline in November 1927.

Today this "moving" theatre is called the Mack and is one of the important satellites of the Confederation Centre of the Arts' active theatre program. The building makes a fine addition to what was long ago known as Smardon's Corner, now the intersection of University Avenue and Grafton Street.

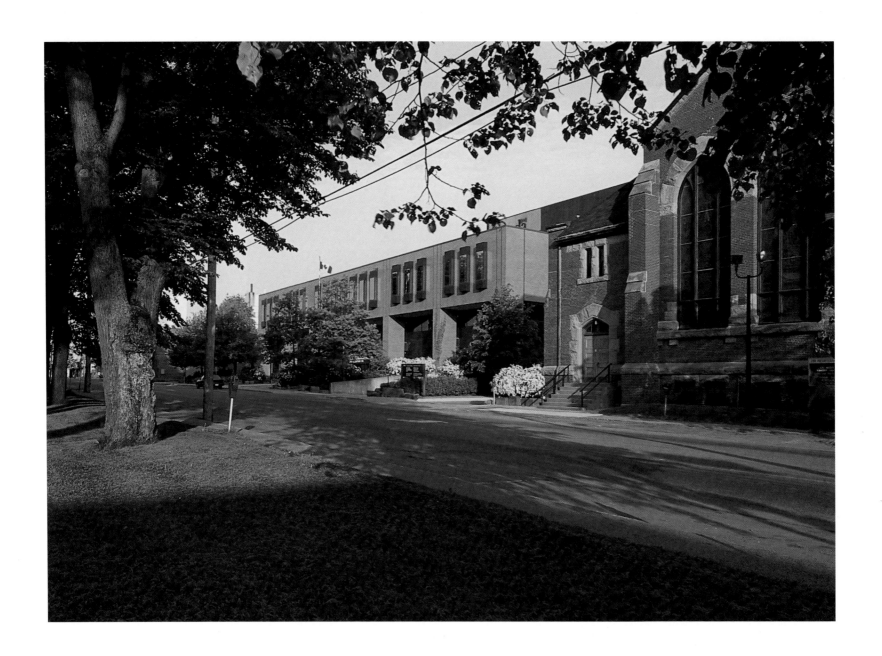

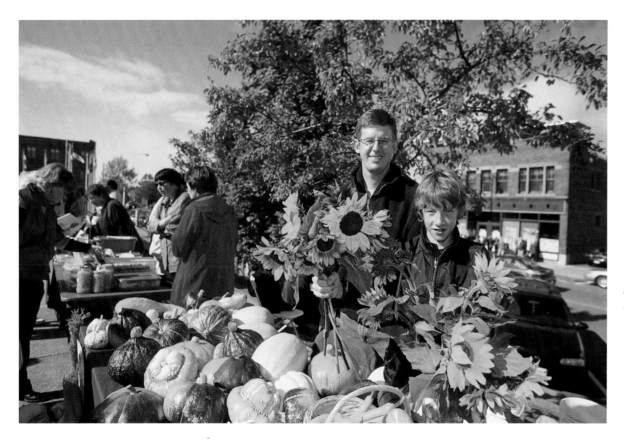

Mr. Weldon placed the following advertisement in the Morning News of May 28, 1845: "Good Seeds—good garden seeds are a matter of some importance in a town where amateur gardening is carried on so tastily and extensively as Charlottetown." He would be pleased to meander up Grafton Street on a summer morning to see results beyond anything he could have imagined. Confederation Centre of the Arts plaza offers a great place for a Saturday morning market.

Facing page: "One of the big improvements of this year is that New Zion has taken the place of Hobbs, the Hatter's old store and sundry other little old places at the corner of Prince and Grafton," states a report in the Examiner, June 13, 1912. Zion Presbyterian Church was joined on the block in 1983 by the Department of Veterans Affairs, adding a strong federal presence to the capital city. The building was called the Daniel J. MacDonald Building, after Danny Dan MacDonald of Bothwell, Prince Edward Island, a former provincial and federal politician and a prominent World War Two veteran.

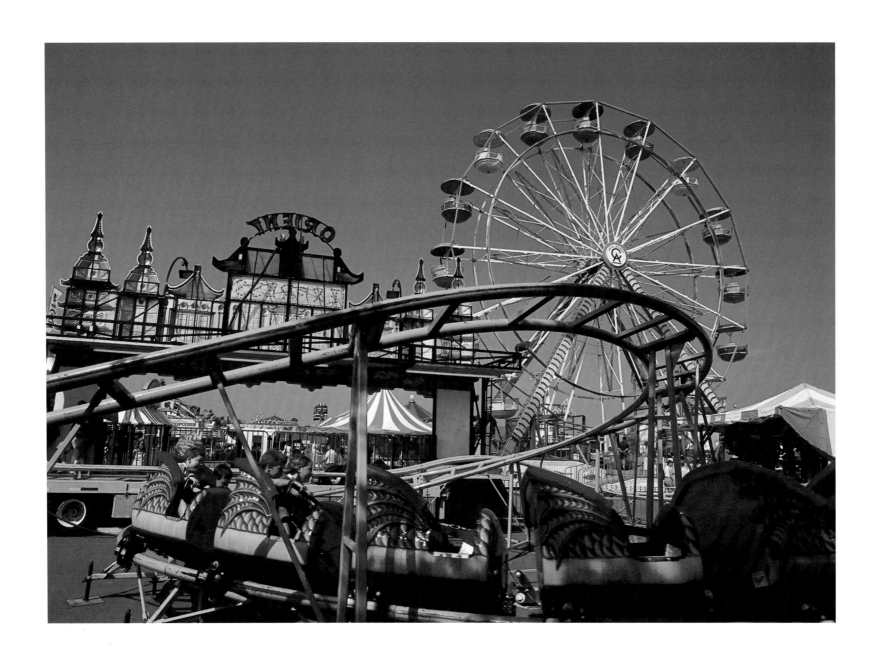

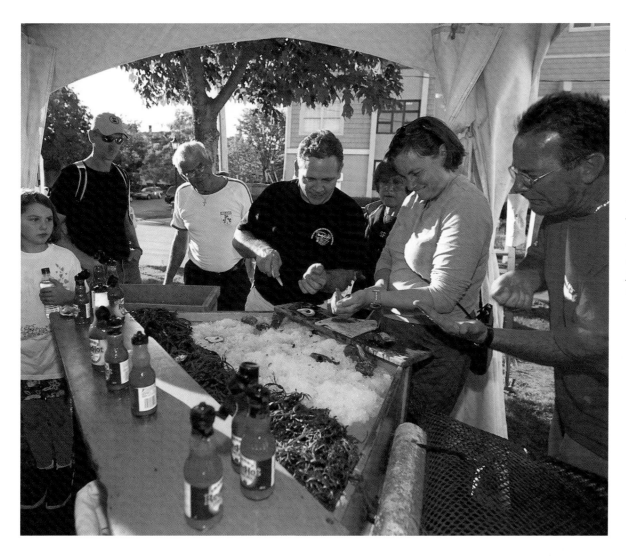

Prince Edward Island shellfish come not only from Malpeque Bay, off the Gulf of St. Lawrence, but also from many other bays and rivers of the Island. The annual Shellfish Festival on the Charlottetown waterfront is a great way to celebrate these culinary delights.

Facing page: Old Home Week, held annually in August, is an event much looked forward to by many. The midway is especially popular with the kids: the outing might result in white knuckles or a sick stomach, but is still looked forward to with great anticipation. It could be that adults, too become kids for this special week. In addition, the horse races, the exhibits of handicrafts and the animal judging all make for an event that Islanders—even those from away—return to happily every year.

Wonderful wooden houses, like the Bremner House on the left, can be found in all parts of town. "In September 1923, M. F. Schurman Company supplied the stock for a handsome new residence on Greenfield Avenue for Mr. Benjamin Bremner. The workman in charge of this job is Harry Williams of Bideford who is turning out a fine example of Prince County workmanship."

From a pioneer family, Benjamin Bremner (1851–1938) was active in business, but his lasting memorials are the books he wrote on Island history, among them Memories of Long Ago *(1930) and* An Island Scrapbook *(1932).*

Facing page: Here are two houses that have been nestled together since the last decade of the nineteenth century. Number 11 Grafton Street was built by William H. Fraser, who was the contractor for City Hall, while 15 Grafton was designed by William Critchlow Harris. Their special architectural details are excellent examples of many that appear throughout the older parts of town.

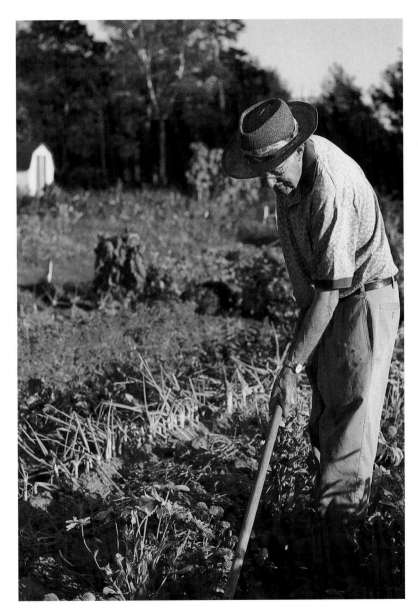

These people at work at the community gardens in the Royalty might be unaware of the strong tradition to which they belong. An ad in the Royal Gazette of August 17, 1841, reads: "I am desirous to establish in the vicinity of Charlotte Town a Horticultural Garden for the benefit and amusement of the Inhabitants of the Town generally, and to secure for them that comfort which they are now deprived of early Horticultural productions both fruit and vegetable." Such sentiments are what motivates those who use the community gardens today. Nearby, along the old rail line, bird watching is a popular diversion as well.

Facing page: Just before Spring Park Stream enters Charlottetown Harbour, it widens into what is known as Government Pond. The pond once stretched from Brighton Road to Christian's Bridge at Government House gate. Today the pond is not nearly as large as it once was, but it continues to add beauty to the area and often, too, fills its traditional role as a skating pond in winter.

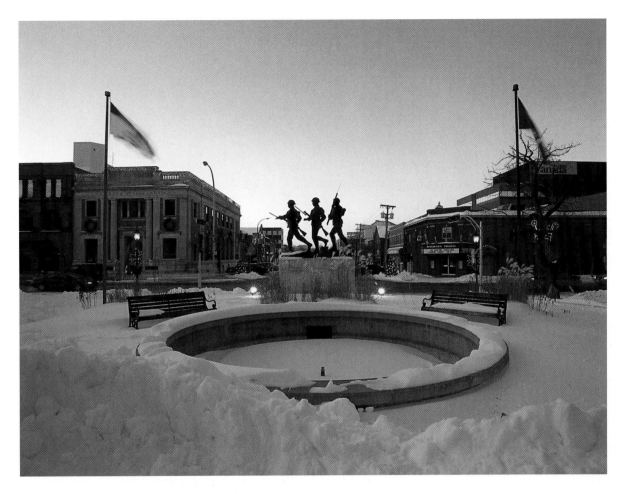

Designed by prominent Quebec sculptor G. W. Hill, Charlottetown's War Memorial was unveiled on July 16, 1925. It took the community more than six years to work through just what shape the monument would take. Today its three soldiers stand protecting Queen Square from the traffic of University Avenue. The monument is a fine tribute to all those who fight for peace in our world.

Facing page: Designed by Thomas Alley, the Provincial Court House was built in the 1870s. The Weekly Examiner claimed "it bids well to be a handsome edifice," while others called it "a hideous building of cotton factory style." The building suffered a serious fire in January 1976 that destroyed the interior and the tower that housed the town clock. The Court House eventually found a new home, and for a number of years it looked as though the original building would be demolished. Wisdom prevailed, and the building, which is situated on Queen Square between Province House and St. Paul's Church, was refurbished. Today it houses offices for the members of the Legislative Assembly, the Opposition Offices and the Provincial Archives. It is now known as the Coles Building, after Father of Confederation George Coles. the man who brought Responsible Government to the colony.

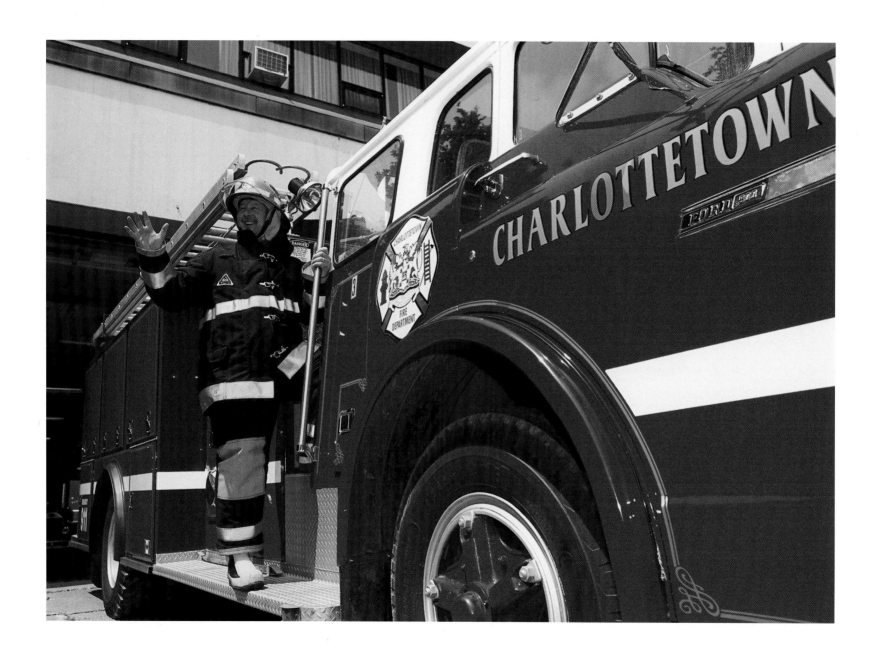

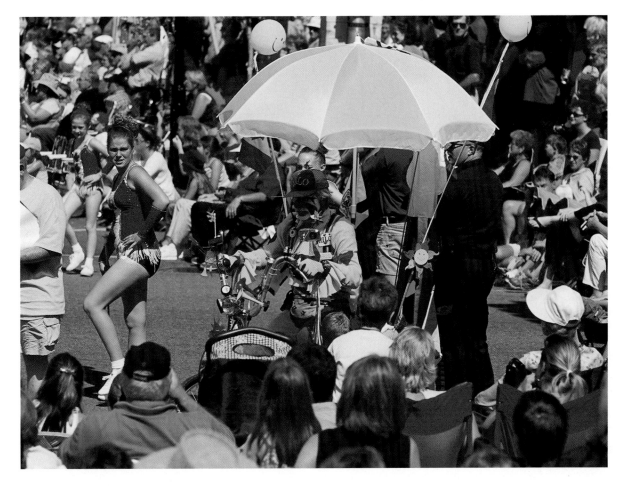

Fire trucks are a big part of The Gold Cup and Saucer Parade held during Old Home Week in August. So are clowns, majorettes, floats and bands. The most unique band in the parade, The Clash, draws the alumni of musical groups from the community out for their annual fling. This band, made up of musicians of all ages, never fails to bring the crowds to their feet.

Facing page: "As a person interested in the welfare of Charlotte Town, I was gratified, a few days ago to see a number of public spirited gentlemen, coming forward to associate themselves into something like a Fire Engine Company, it is what has long been wanting in this wooden town." This letter to the editor from the PEI Register, February 1824, reflects the enthusiasm and spirit of the volunteer fire department that endures to this day.

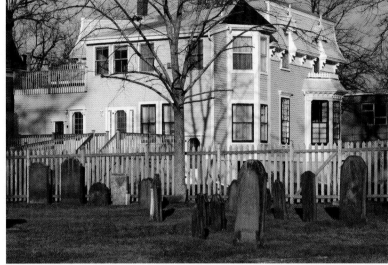

The George Full House has been a landmark on Upper Prince Street since it was built in 1887. The back of the house overlooks the Old Protestant Burying Ground—most recently referred to as the Elm Avenue Cemetery. From Colonial Days until it closed on December 31, 1873, it was the resting place for many early Charlottetown citizens.

At left: Trinity United Church was built in 1863, and so is the oldest church building in town. Its façade is one of exceptional symmetry, and it is almost reflective of the fine cabinet work that Mark Butcher, one of its designers, put to his furniture.

Facing page: Asked to produce a sculpture for the Confederation Landing Park, artist Chris Phillis was obviously influenced by the stories of ship masts dotting the waterfront in the days of sail. Phillis's masts do not carry sails, but a collection of ceramic flags that represent the provinces and territories of our country.

The story of Colonial Secretary William R. Pope rowing out to the Canadian steamer Queen Victoria *to welcome delegates to the Charlottetown Conference in 1864 is often told. Local sculptor Chris Phillis captures that moment in the sculpture that dominates the lower end of Confederation Landing Park on the Charlottetown waterfront.*

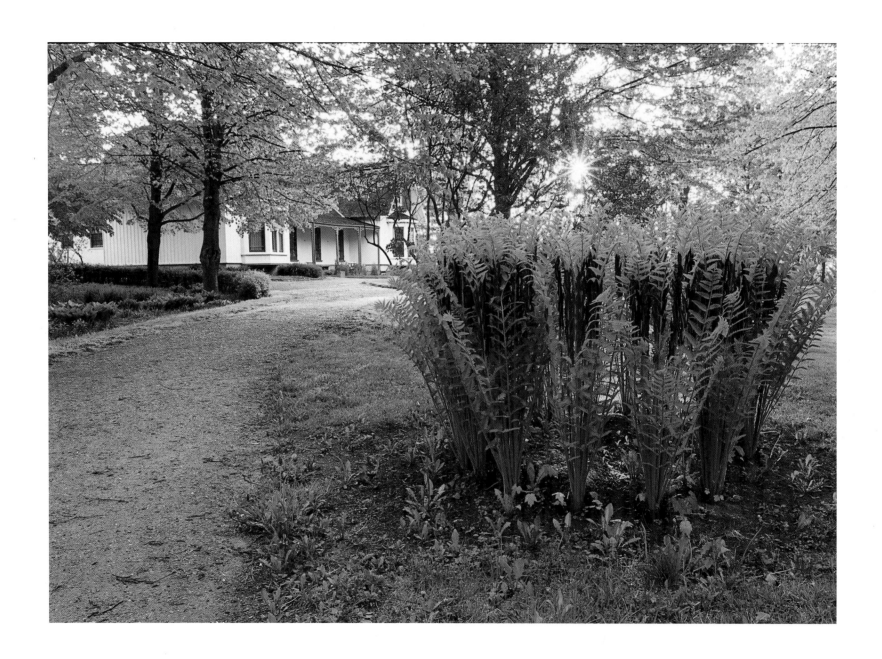

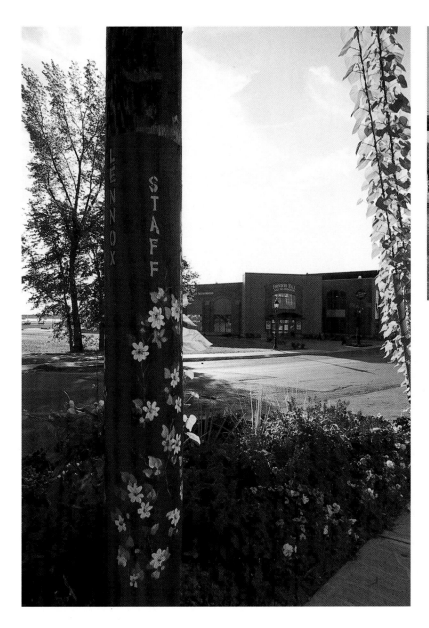

Behind a playfully decorated light pole is a building that holds great memories for old railroaders—it was the car shop, the heart of the place.

Here rail cars were repaired, reconstructed and even built from scratch on a round-the-clock schedule. With the railway gone, the building has undergone a great transformation. Now called Founders Hall, it houses an interpretive centre that pays respect to the Fathers of Confederation and the evolution of our country.

Facing page: At Ardgowan, in the St. Avard's area of town, Father of Confederation W. H. Pope welcomed Confederation Conference delegates to his home at four o'clock in the afternoon on September 2, 1864, for déjeuner à la fourchette (luncheon with fork), which included oysters, lobsters, champagne and other island luxuries. Ardgowan, built circa 1850, has been restored and is now occupied by Parks Canada. The house itself is an excellent example of the Picturesque style that would have appeared especially grand in Prince Edward Island at that time.

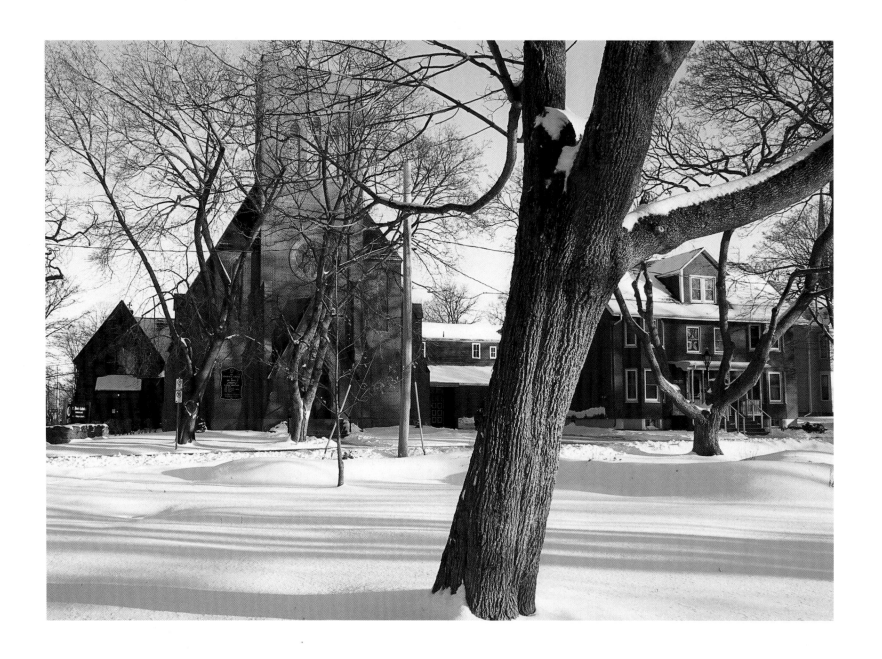

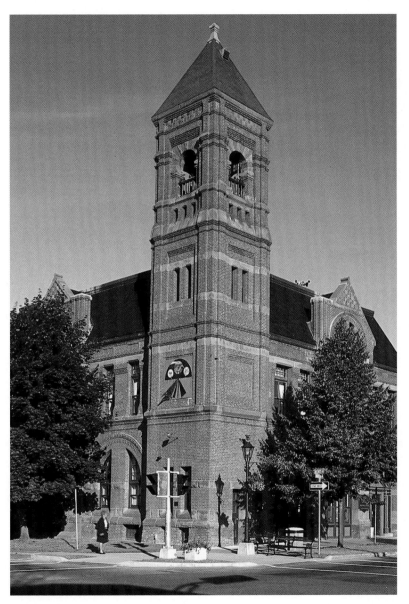

After the city's incorporation in April 1855, the town set up business in the 1812 Court House that was once on Queen Square. A few years later, the city offices moved into the wooden market building nearby. This moving about was not acceptable for a growing community, and a permanent home for a city hall was needed. In 1887 Love's Corner was acquired and architect Phillips & Chappell was hired to design a building. Built of Island brick, this handsome structure dominates Queen Street with its eighty-five-foot hose tower. It was designated as a National Historic Site in June 1988.

Facing page: The Cathedral Church of St. Peter's, overlooking Rochford Square, was founded in 1869 as a result of the Oxford Movement in England. "It is unique in many ways. It has had a surpliced choir practically ever since it was opened for services. As early as 1873 the rood screen was erected and the seven lamps placed in the sanctuary…the outstanding and unique attraction, however which St. Peter's holds for tourists, visitors, lovers of good painting and carving is All Soul's Chapel. The cornerstone for it was laid in 1888…" from a lecture given to the Prince Edward Island Historical Society by Canon E. M. Malone in February 1962. The canon had served St. Peter's from 1921 to 1952. All Soul's Chapel is always a quiet refuge in the midst of a busy day.

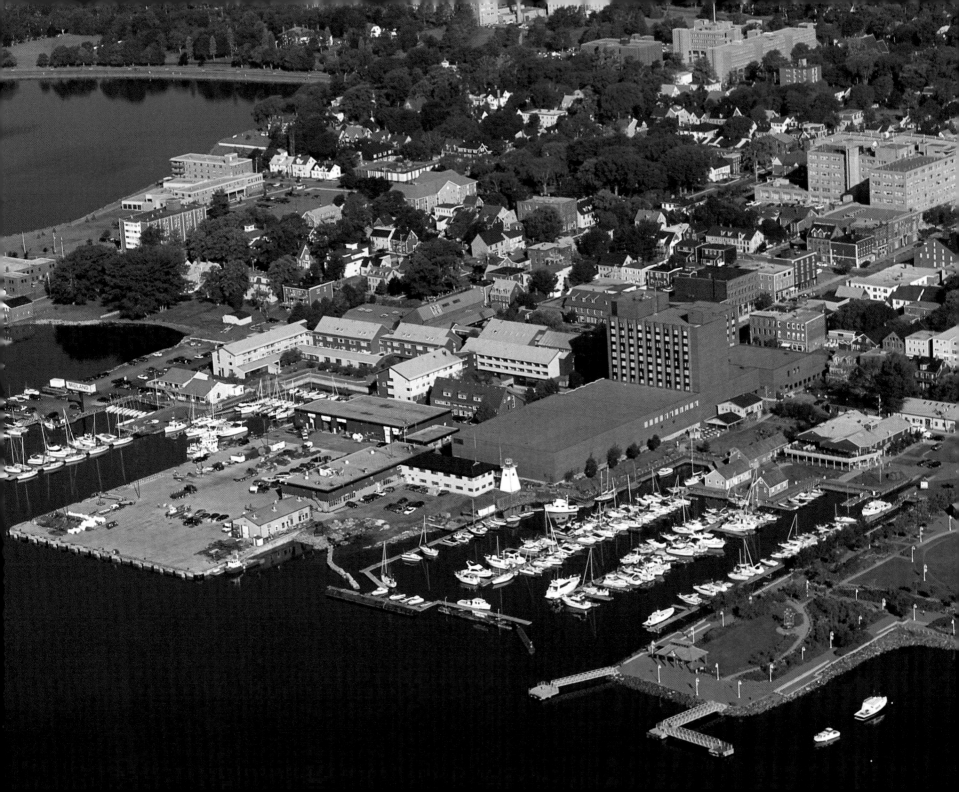

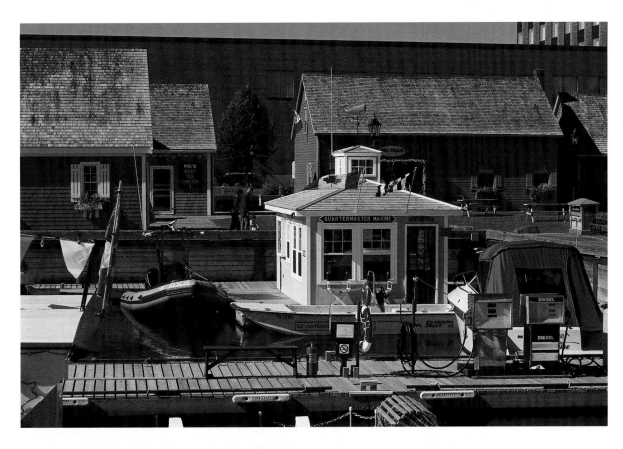

Sailing yachts and powerboats from across the eastern seaboard can be found moored at Peake's Quay. From here, you can take a cruise of Hillsborough Bay or browse the collection of shops that occupies the old wharf where Peake ships came and went in the great days of sail.

Facing page: Returning to Prince Edward Island by air, one knows one is home when this view appears below. "The little town that rolls down to the sea" is foremost in the scene. It is not hard to see, in retrospect, why Samuel Holland was drawn to Charlottetown's appealing waterfront when he chose the site as the Island's capital so many years ago.

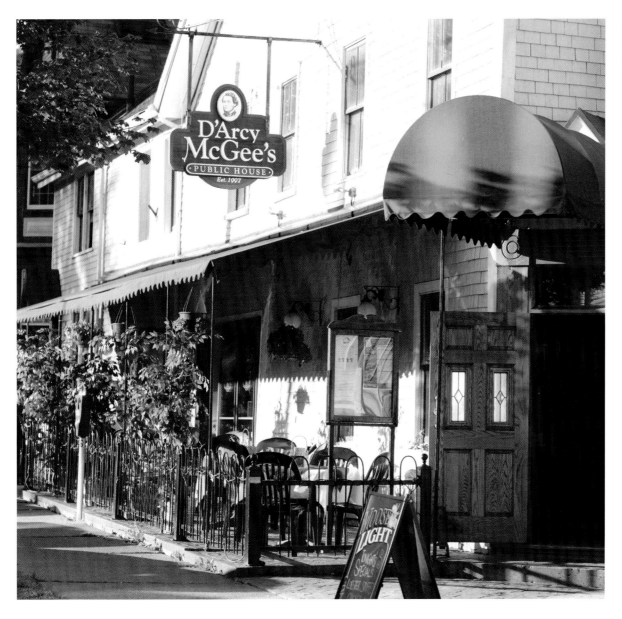

Stores, restaurants and bars have taken over many of the older buildings in the downtown core, adding new colour and vitality to the area. Some of the names of these local places are created out of the blue, while others, like D'Arcy McGee, forge historical links. McGee, of course, attended the Charlottetown Conference.

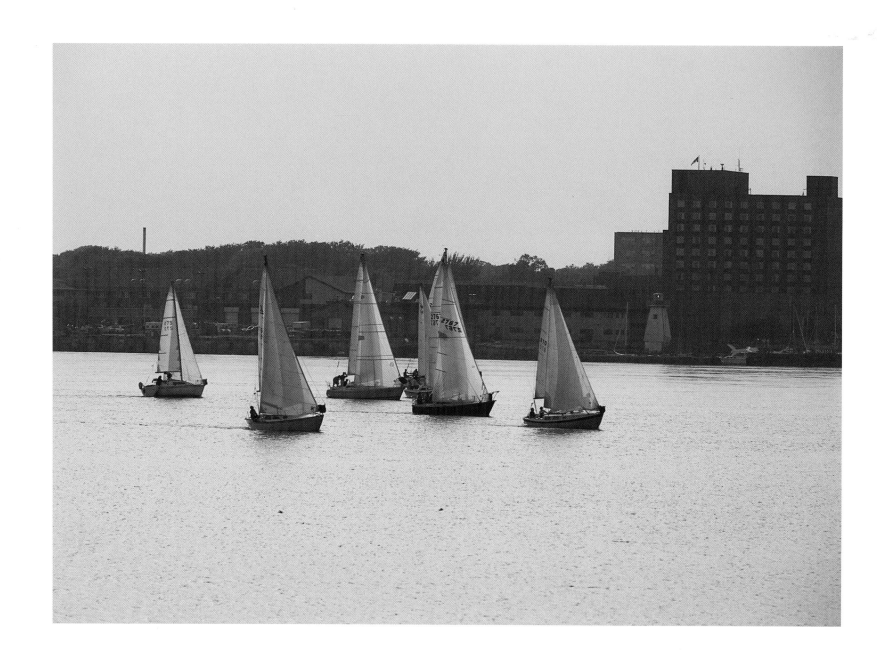

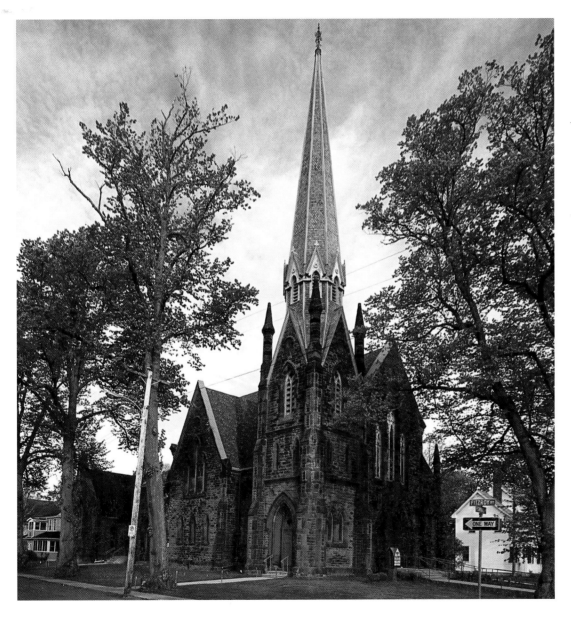

"A sabbath in this fine old city by-the-sea made an memorable day with an opportunity to visit for the first time the auld Kirk—St. James—and to admire its setting in stately trees and the dignified architecture of the red stone edifice. The interior flooded with the glorious summer sunlight revealed the vivid richness of the stained glass windows," from an article written in the Guardian, September 22, 1922, under the title "Where folks go to church."

Facing page: The Wednesday night Charlottetown Yacht Club Races occur weekly during the summer months. They bring out the competitive spirit of the participants and give joy to those who watch from the shore.

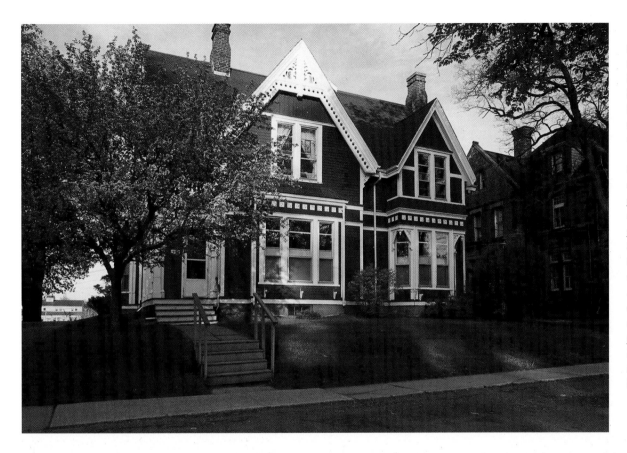

"I would say that Charlottetown people love their houses," explained an early visitor to the town. There is no question that Mrs. MacLennan, relict of Rev. John MacLennan, loved the house that she built in 1886. Designed by Stirling and Harris, the building has so many extraordinary and playful features that one must look very carefully to find them all.

Facing page: Rochford Square is one of the five squares created when Charlottetown was planned in 1771. When Charlottetown first celebrated Arbor Day in 1884, 110 trees were planted in this square, which faces government buildings on Pownall Street. Today the square holds less than 60 trees, not all with their roots dating back to 1884, but beautiful nevertheless. In recent years, stakeholders—by and large, neighbours—declared their belief in green spaces and made a commitment to beautify this precious piece of open space in the town. Now, Rochford Square hosts an impressive Victorian-style garden, perfect for romantic strolls or as a backdrop for photo-taking.

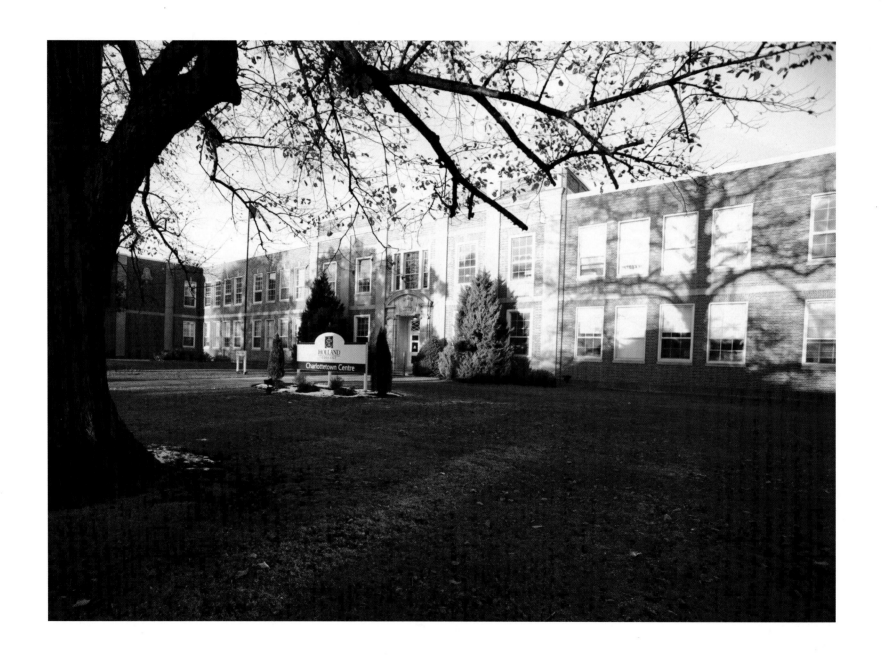

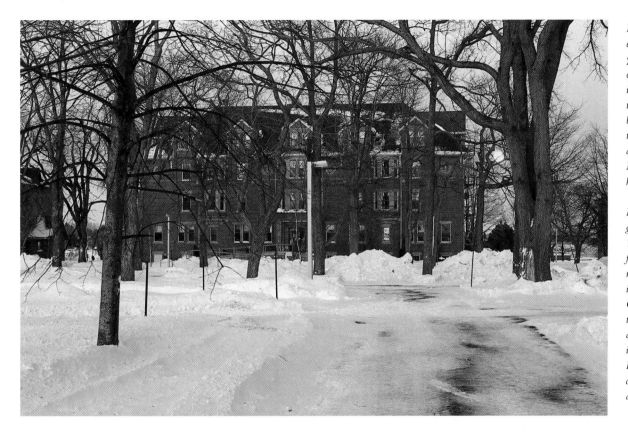

Built on land that has been part of the higher education system of this province since the early years of the nineteenth century, the University of Prince Edward Island (UPEI) makes an important contribution to the vitality of the town. UPEI president Wade MacLaughlin believes strongly that if Prince Edward Island is to do well in the knowledge age, UPEI must also do well. A graduate himself of UPEI, MacLaughlin is working hard to see that we have "a great small university."

Facing page: Prince of Wales College (PWC) grew out of the Central Academy, established in 1834. This building was built in the 1930s after fire destroyed an earlier one. Local headlines read: "Atmosphere of Colonial Days Retained in Design of the New Prince of Wales College." Thousands of Islanders passed through the doors of this junior college. In 1969, shortly after PWC had become a degree-granting institution, the University of Prince Edward Island was created, and moved to its new campus. This building became Holland College and the Island's new community college.

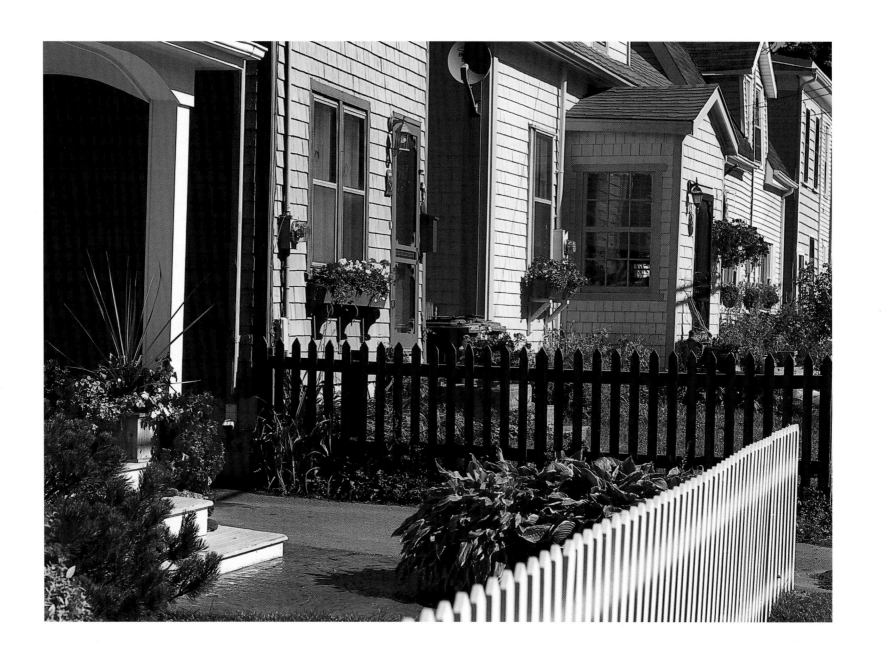

On the front lawn of this 1916 house on Rochford Street, these trees and the hedge must have been the owners' answer to The City Beautiful committee's call. There was a push for hedges, more trees, flower beds and backyard gardens. They had noble goals, too, according to a 1919 editorial in the Guardian: "Love of the beautiful is a virtue and one cannot go far astray in morals, in religion, in patriotism who looks for the beautiful in nature, in art and in man and woman. Behind the movement of the City lies the great missionary spirit whose aim is to redeem the world from the last vestige of spiritual, moral and material ugliness." No wonder they planted trees.

Facing page: On March 19, 1835, a Member of the House of Assembly by the name of William Douse declared: "A mighty house might as well be without a fireplace as a garden without a fence around it." The occupants of this contemporary streetscape must also believe in the importance of fine details, such as neat picket fences and lush window boxes. Their efforts certainly give joy to passersby.

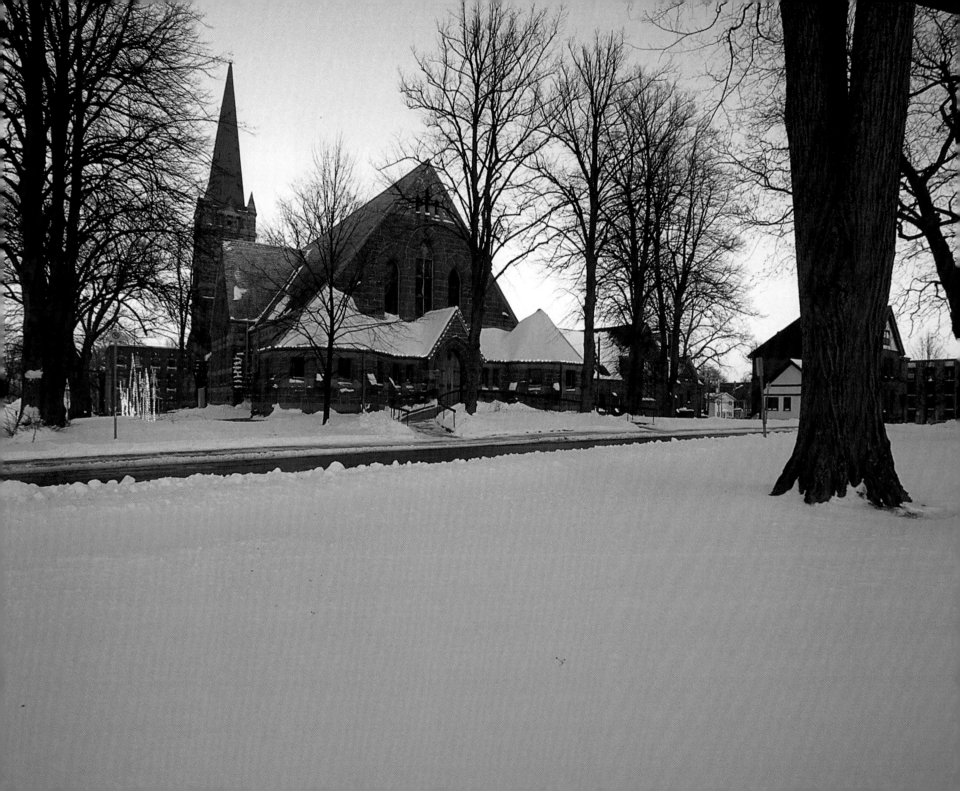

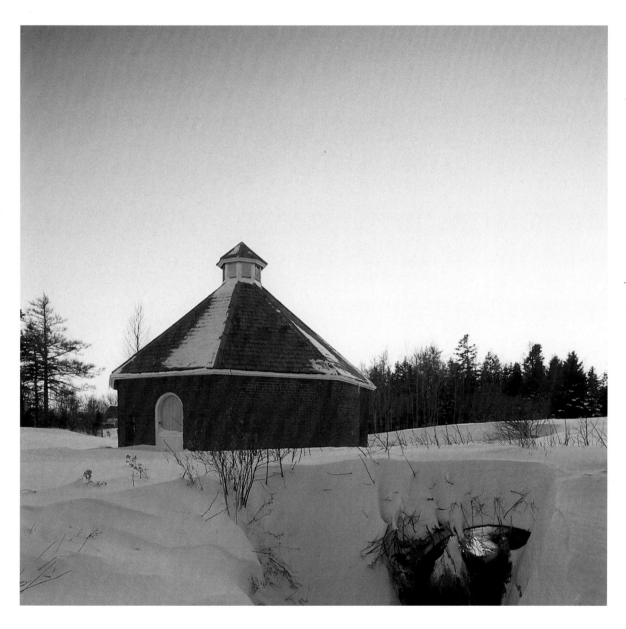

The Charlottetown Water System dates back to 1887. Interestingly, it took over twenty years of debate for the community to finally agree that the system was needed. The city acquired the professional advice of Boston engineer Freeman Coffin. This octagonal-shaped pumping station on the Malpeque Road is an architectural treasure that reflects other Coffin projects in New England.

Facing page: As an institution, St. Paul's dates back farther than all oher churches in the town. Its location in a place of prominence—on Queen's Square, in the heart of downtown—is no accident: In colonial times, the Anglican Church was the established church and therefore figured prominently in developing towns. This charming 1895 church designed by W. C. Harris is the third St. Paul's church on Queen Square.

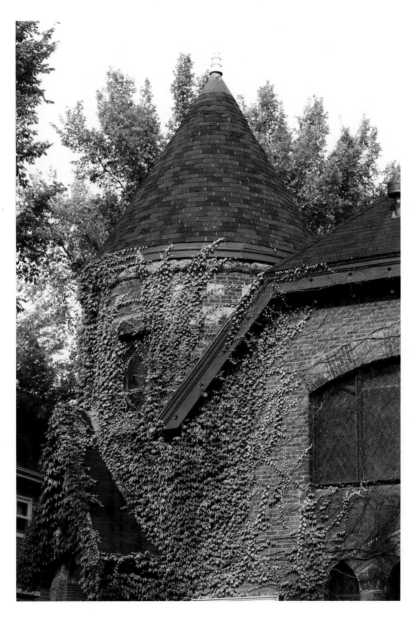

"The new church built by the Christian Church congregation will be dedicated tomorrow. The church is one of the most beautiful in the province…inside work is perfect and reflects great credit upon the contractor H & S Lowe," states the Examiner, *September 22, 1900. This church is one of the many designed by architect W. C. Harris. With Virginia creepers softening its façade, the building makes an especially fine contribution to Kent Street.*

Facing page: Built in the mid 1820s, this exceptional, well-preserved house has many stories to tell. The original owner, John Edward Carmichael, son-in-law of Lieutenant-Governor Smith, died in 1828. The house later became home and office to important Island surgeon Dr. MacKieson. The MacKiesons occupied the fine historic home for over sixty years.

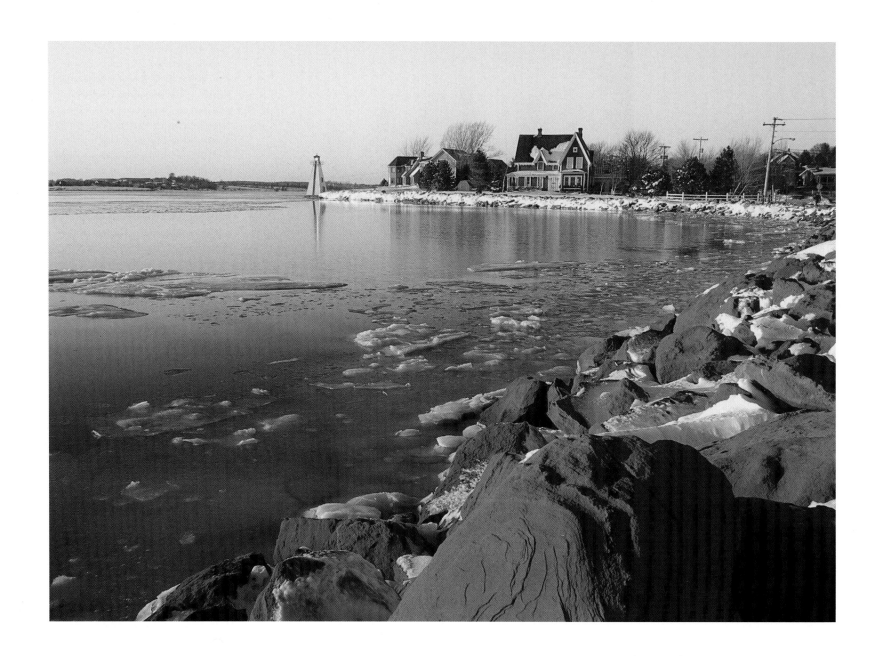

Hermitage Creek flows into Ellen's Creek and both were named after early estates that were once in the West Royalty area. These creeks add much to their surroundings while creating a haven for wild life. Charlottetown Rural High School has the advantage of using them as a rich educational resource.

Facing page: The range light on Brighton Shore is part of the navigational system that directs boats in and out of Charlottetown Harbour, standing like a guard of the upper reaches of the North River. The house to the left, called Watermere, was built by Frederick W. Hyndman in 1877. Hyndman was a member of the Royal Navy who had travelled the world before settling down on this piece of land and becoming one of Charlottetown's prominent businessmen. Watermere is a tribute to him as is the insurance company he founded.

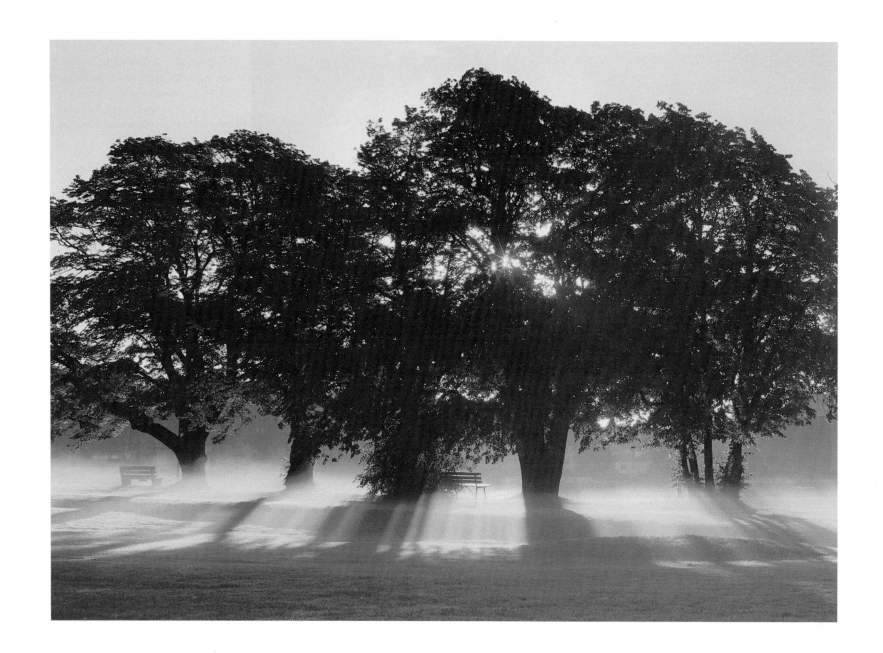

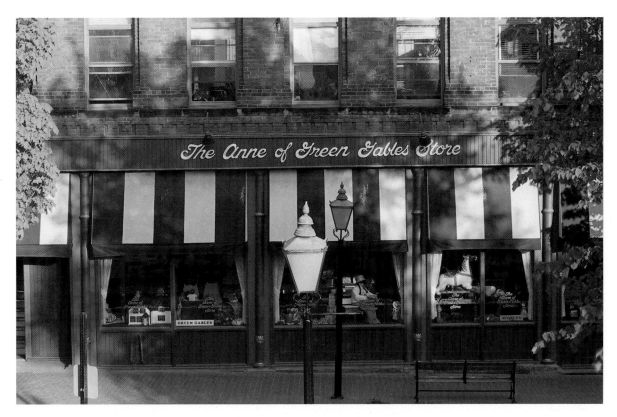

Housed in what was once called Prowse's
Corner, this Anne of Green Gables store
attracts L. M. Montgomery fans from all over
the world. Situated across from the
Confederation Centre, where Anne of Green
Gables the musical plays all summer long, the
store is a natural stop for Anne fans.

Facing page: "The splendid Victoria Park—
that beautiful stretch of forty acres or more of
wood land, lawns, amusement and parade
grounds and which faces our magnificent
harbour is the great, free and unspoilt breathing
place for our citizens," Guardian, July 25,
1947. This photograph, showing the magic of
the sunlight in the trees, demonstrates how
Victoria Park's inspirational beauty remains
undiminished today.

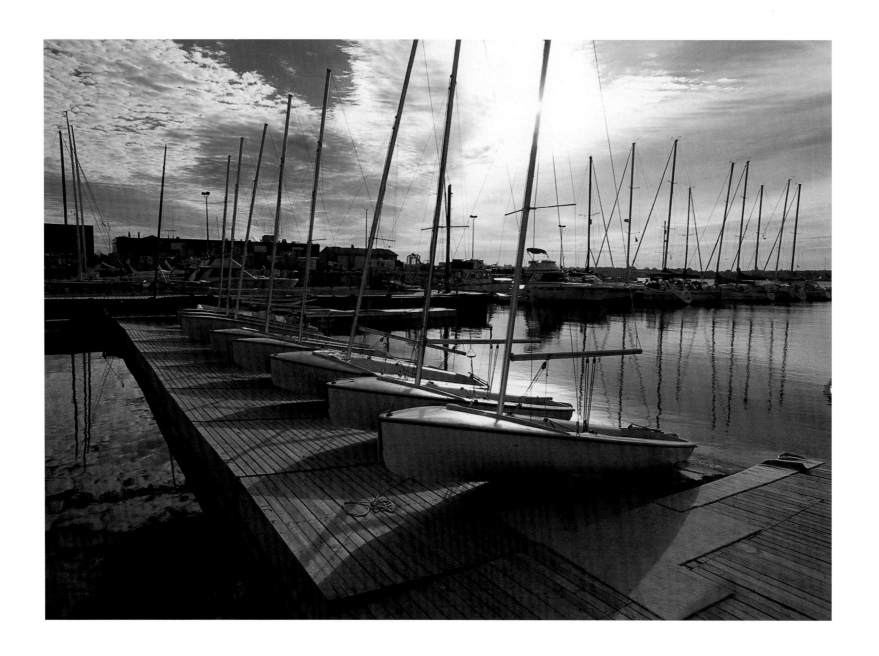

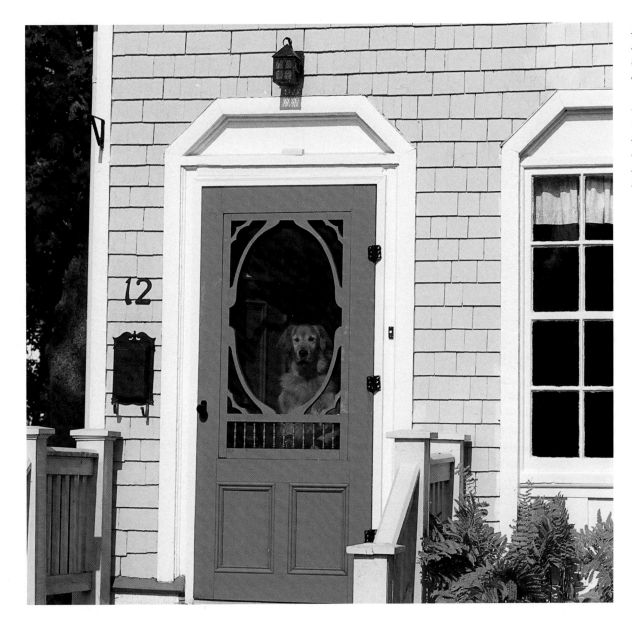

A favourite family pet is framed by a decorative screen door. A survey of the variety of doors in the older parts of town is an interesting way to add to a pleasant evening stroll.

Facing page: For over forty years the Charlottetown Yacht Club has held a junior sailing program each summer. With these 420s, kids from all over the county—and beyond— sharpen their sailing skills and develop a healthy respect for the sea.

"Since their occupancy of Government House, His Honour Lieutenant Governor George DeBlois and Mrs. DeBlois have taken special interest in beautifying the grounds. This labour of love has been well rewarded, for today, at this mid summer season, no finer beauty spot can be found in all of Canada than our Government House Garden…those who love flowers, be they citizens or strangers, have been made to feel that the gardens at Government House are there for their special joy and pleasure." So stated the Guardian *editorial of August 1, 1939.*

The garden has been improved continuously and is still open for public enjoyment. Well supported by the incumbents, it is truly a beautiful place.

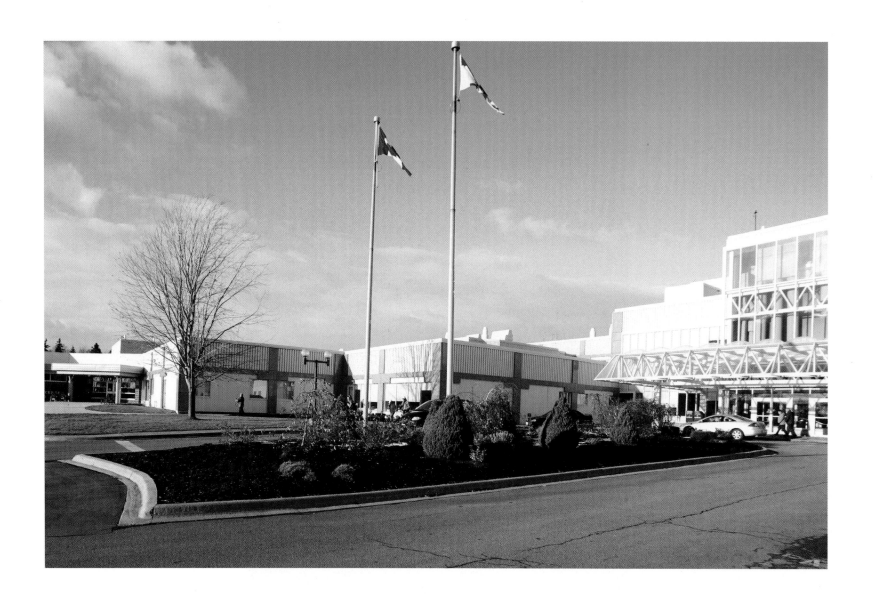

With a history that dates back to 1879, this modern hospital facility has grown out of a long and dedicated line of caregivers in the community. The handsome building is built among the trees not far from the Hillsborough River, adjacent to the property called Falconwood, which has an interesting history of its own. In 1870, the Island government invited a seriously ill Sir John A. Macdonald to recuperate at Falconwood. Early in July, he arrived accompanied by Lady Macdonald, family members, and physician Dr. Grant. The family spent the summer at Falconwood, and Sir John returned to Ottawa in September a much improved man.

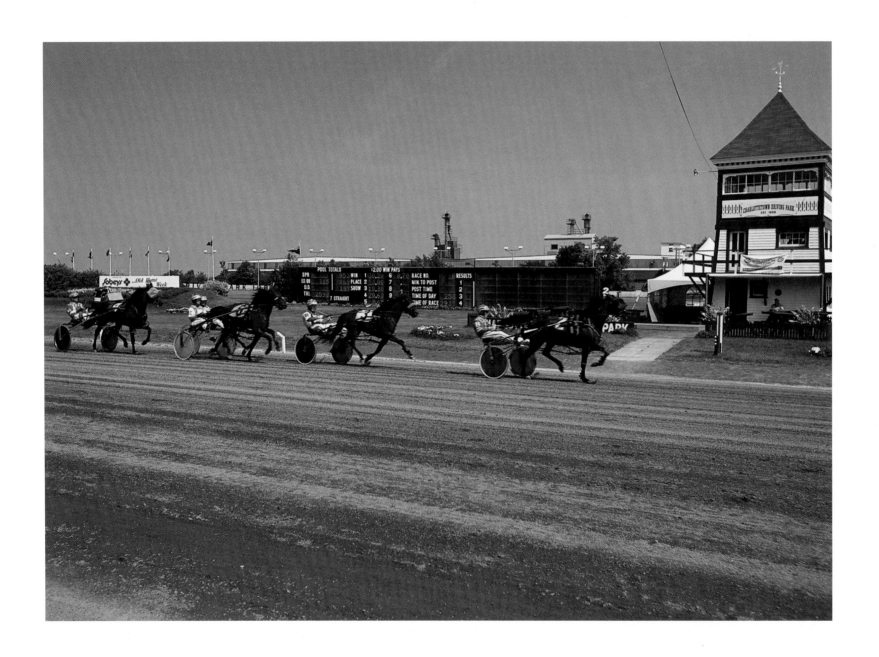

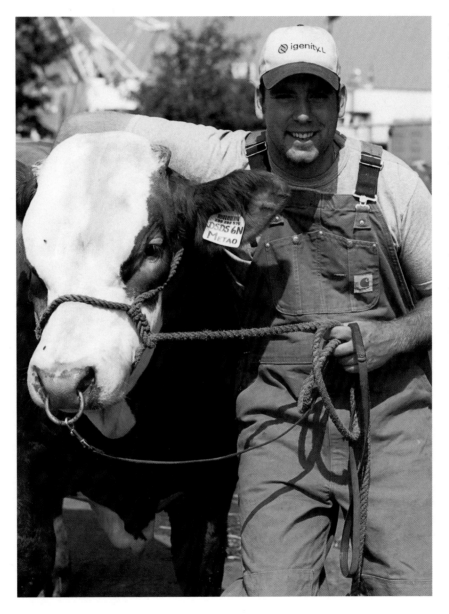

Animal judging at Old Home Week is an important tradition that dates back to the early years of the colony. The Provincial Fair held in the capital city certainly shaped itself from the Royal Agricultural Society, which first met in Charlottetown on March 24, 1827. The role of the fair was thus expressed by the society: "To diffuse and extend the knowledge and promote the practice of the best and most approved modes of agriculture...." Judging by the excellent quality of livestock and farm harvests seen annually at the fair, such high ideals are still taken seriously.

Facing page: Horseracing has long been a special love of Islanders. The Charlottetown Driving Park was established in 1888 on a piece of land overlooking the Hillsborough River. The recently renovated judge's stand is the central landmark of the park. Here, on a summer night, you can enjoy the breeze from the river; and, if you are lucky, the moon will rise, making for a splendid sight.

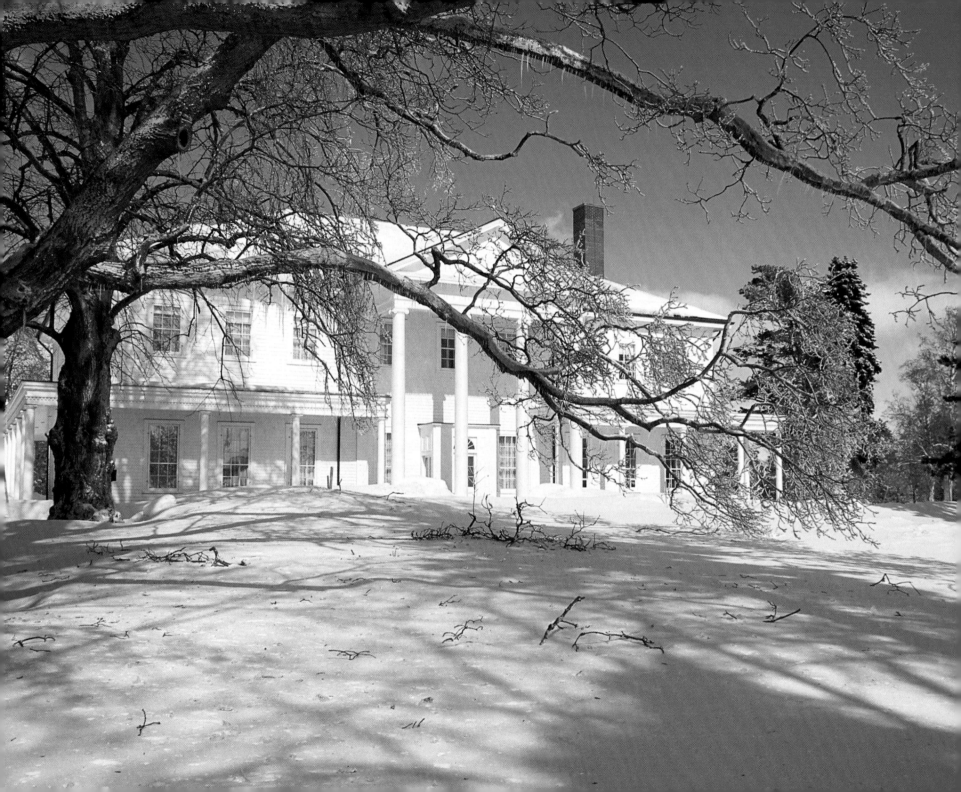

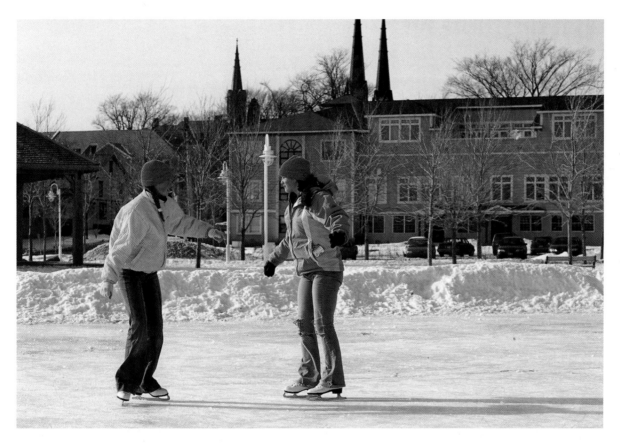

A warehouse, taken over and made into office space for a local law firm, has an address on prestigious Great George Street with a view of Confederation Landing Park. Hopefully, the hard-working lawyers are inspired by the winter-time exercise of these two young women.

Facing page: Fanningbank was built as a home for the lieutenant-governors of the colony—thirty-two have lived here since the residence was completed in 1834. Through the years it has welcomed people from all over the world and from all walks of life. One of its great historical moments occurred when the delegates to the Charlottetown Conference gathered to be photographed on the front steps on the morning of September 6, 1864—one of Canada's most historic photographs.

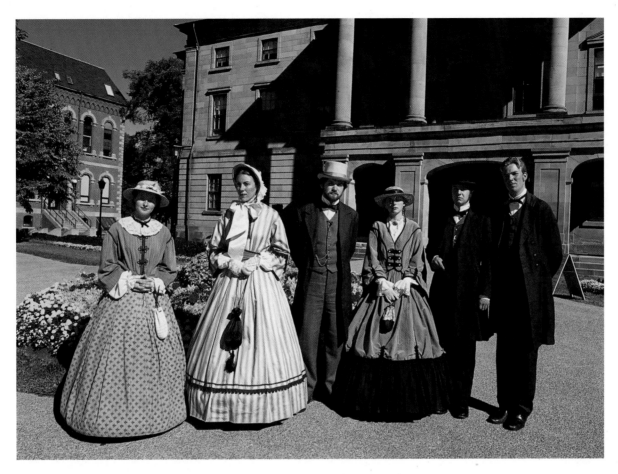

Street theatre is an integral part of summer in Charlottetown. You don't have to go far before meeting the Fathers of Confederation out for a stroll with their lady friends. If you're lucky, you'll be able to listen in on a discussion that recalls one of the serious matters foremost on their minds in 1864. Seeing the players' colourful costumes against Charlottetown's historic streets brings history the life.

Facing page: The scale and variety of building materials used on this block of Water Street make for one of the more interesting streetscapes in the town. This little house at 100 1/2 Water Street was occupied by a veterinarian, and the wooden doors once allowed access to his office in the backyard. In an early twentieth-century town, the horses alone would have kept a vet busy.

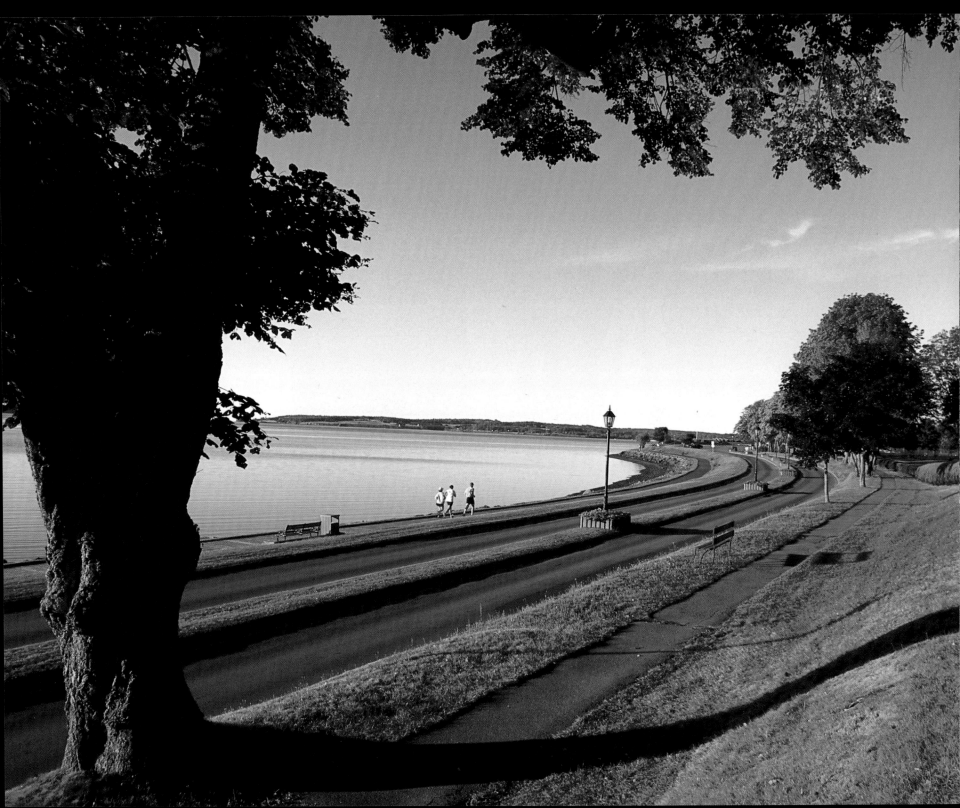

The imposing Connolly Building stands at 75 Queen Street, with a sculpture of its namesake, Owen Connolly, erected on its roof. Though Connolly ended up a prosperous entrepreneur from Ireland, he had humble beginnings. Upon moving to Charlottetown in 1852, he opened a small grocery store, and became active in the business community. He died in 1887 one of the wealthiest men on the Island. This building stands, appropriately, in the business district of Charlottetown, and was built by his estate from 1889 to 1890.

Facing page: "The extension of the Victoria roadway to Brighton Road is an extension for public convenience and pleasure that will be appreciated." So stated the Daily Examiner in May 1903. And indeed it has given pleasure, and continues to, as many Charlottetownians take the opportunity to drive around the park just to enjoy its beauty.

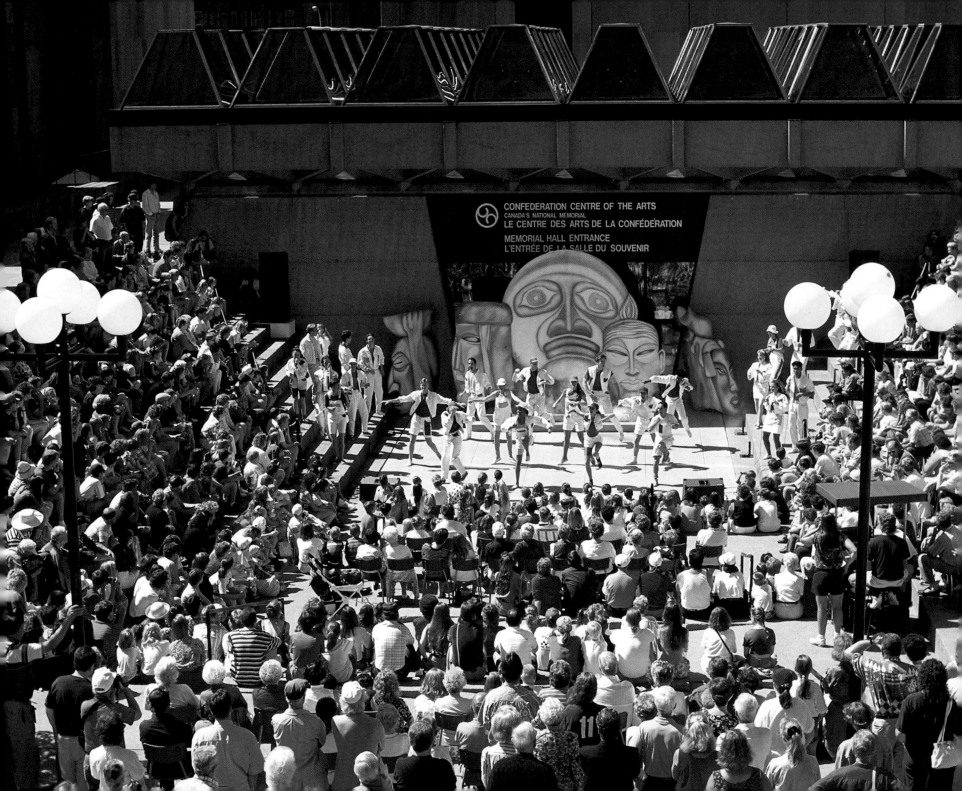

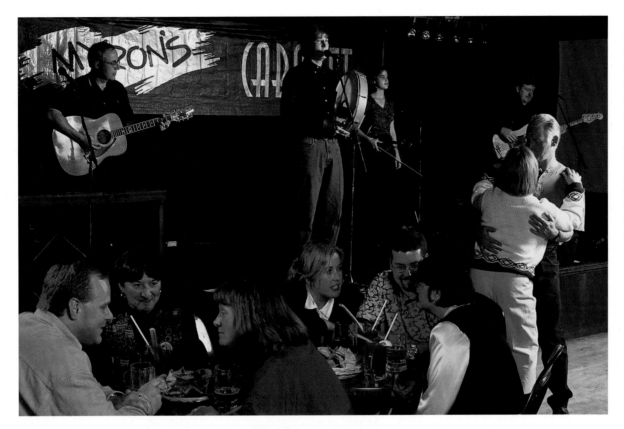

Myron's has been an important part of downtown Kent Street since Milton's Old Spain Restaurant opened its doors on this site in 1926. Now owned and operated by Milton Bell's grandson, it continues to be a popular social centre in town. Begun as a tea room, today it is Charlottetown's largest night club.

Facing page: The Confederation Centre's Young Company performs outside Memorial Hall each summer day at high noon. The vitality and talent of these young people from all over Canada delight the many who gather to watch their performances. Judging from the attentive crowd, their spirit is catching.

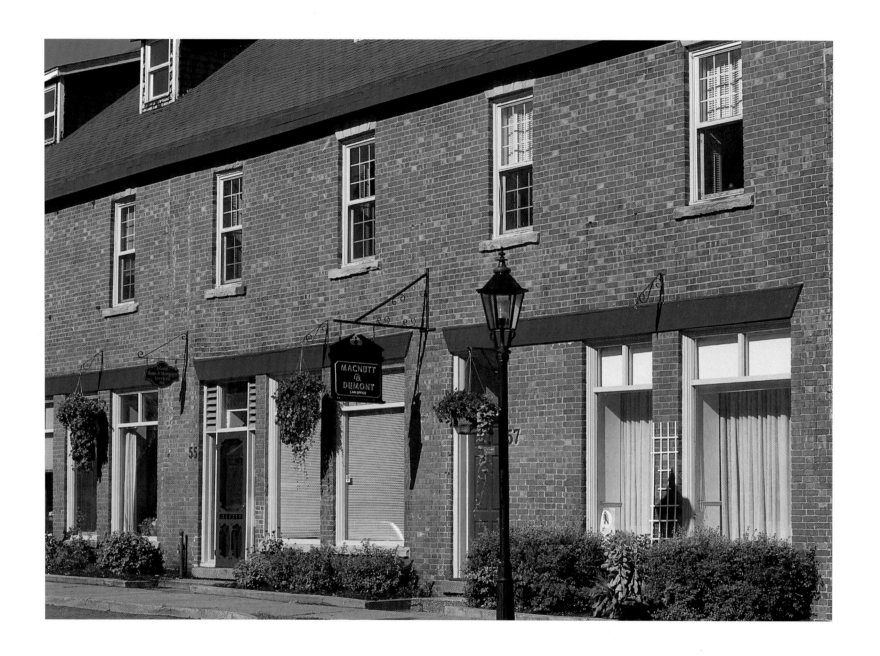

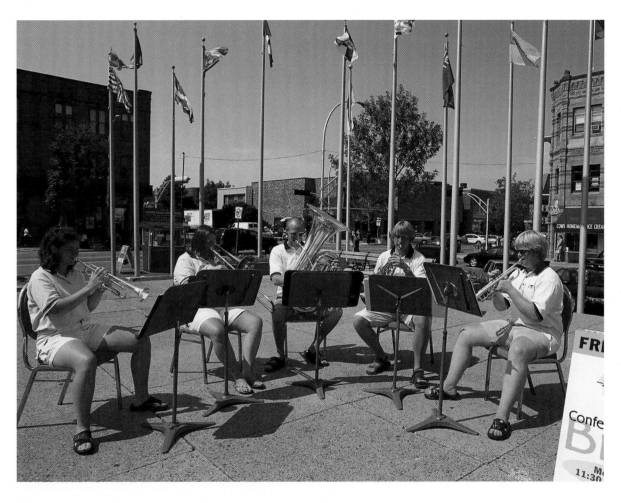

With cultural resources in the community such as the Confederation Centre of the Arts and the School of Music at UPEI, it is not surprising that street performers abound in the summer months throughout Charlottetown. Imagine performing for the enjoyment of passersby, then spending the rest of the afternoon at the North Shore beaches. Not a bad way to pass a summer.

Facing page: Built on the site of the former Victoria Hotel, which burned in 1859, this brick building has been home to a number of businesses over the years, including a wine importer, a coal merchant, and an export company. In later years, it housed Seaman's Beverages, a successful soft drink bottling company. As such businesses moved to industrial parks, buildings like this one have become office buildings, creating new activity in the downtown.

Overleaf: As the sun sets over Charlottetown, the outline of the old skyline competes with signs of today's technology. An urban space is a constantly evolving one.

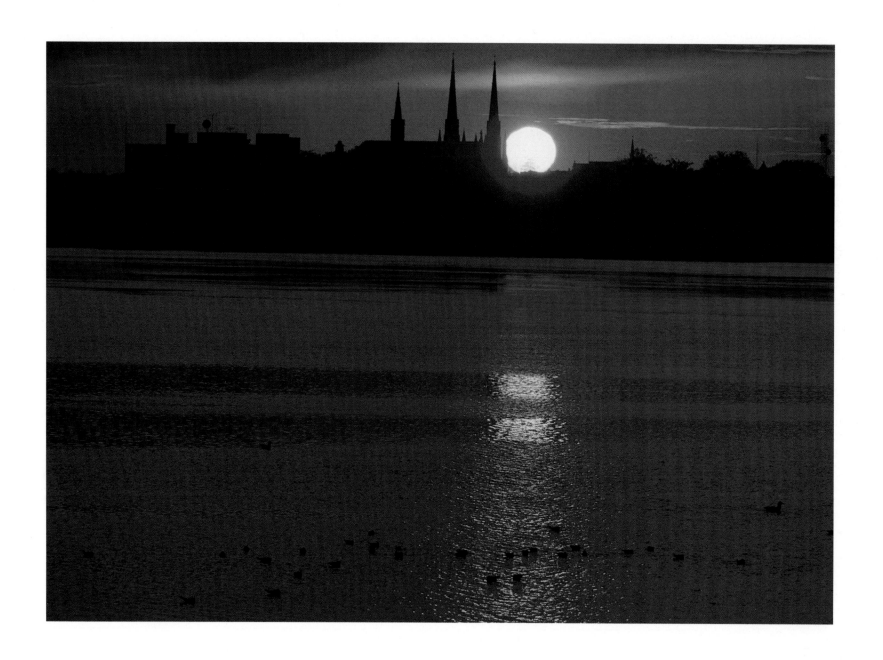